Contents

Better Outdoor Portraits

The great outdoors isn't necessarily always great for making portraits. Here's how to take advantage of the benefits and avoid the pitfalls.

Outdoor portraits can be gorgeous or they can be squint-eyed snapshots. Surprisingly, taking *good* pictures of friends and family members doesn't require lots of expensive equipment. You just have to look carefully at the quality of the light, and know how to work with it. The two photographs below show you what we mean.

WATCH THE LIGHTING

The sun can illuminate your subject in two different ways. First, there's the direct light of the sun, which on a clear day gives the same kind of harsh lighting and deep shadows that you'd get using a single photographic lamp indoors. Second, there's the soft, diffused sunlight that shines down through an even blanket of clouds or overcast.

Neither extreme is ideal for portraits. On a totally clear day—the kind that's perfect for landscape photographs—the light is too contrasty for portraits unless you soften it by adding illumination to the shadow areas. On a heavily overcast day, however, the light is so dull and flat that there's no impression of texture or three-dimensionality in photos. The best choice is usually a day that's slightly overcast, but when there's enough direct light from the sun to create some soft shadows.

AVOID FRONTAL SUNLIGHT

Whether the day is clear or hazy, working with direct sunlight means you have to pay attention to the direction of the lighting. Rule number one is: Don't have your subject face the sun directly.

Facing the sun will almost certainly make your subject squint. It may also lead to deep shadows over the eyes. This is not good, because the eyes are key features in any portrait. Facing directly toward the sun also eliminates the modeling and three-dimensional

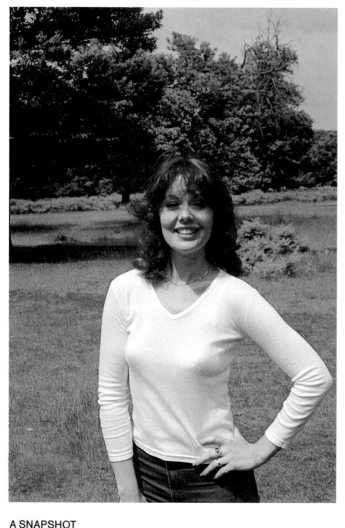

A SNAPSHOT
This is the kind of result you're likely to get if you just aim and shoot. The subject is too small in the picture because a standard 50mm lens was used from about 8 feet away; direct sunlight leads to harsh shadows across the face; and the background is distracting.

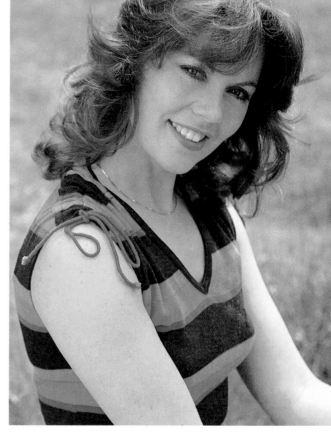

A PORTRAIT
Here a telephoto zoom lens was used to give tighter, more effective framing without the need to move too close to the subject. The sun was behind the subject. A reflector was placed in front of her to provide even illumination for the face. The sun added attractive highlights to the hair. The pose is appropriate and pleasant.

How to
TAKE PICTURES
LIKE A PRO

How to
TAKE PICTURES
LIKE A PRO

Executive Editor: Rick Bailey
Editorial Director: Theodore DiSante
Editor: Vernon Gorter
Art Director: Don Burton

Published by H.P. Books, P.O. Box 5367, Tucson, AZ 85703 602/888-2150
ISBN O-89586-198-4 Library of Congress Catalog No. 82-83103
©1982 Fisher Publishing, Inc.

effects that lighting from the side produces.

USE REFLECTORS OR FILL LIGHT

It's better to turn your subject so the sun shines from the side. You can even shoot with back lighting, provided you use an effective reflector to bounce sufficient light back toward the subject's face. This produces a flattering soft light on the face, and gives an attractive rim light to the hair. With sunlight from the rear, you can also use flash to illuminate the front of the subject.

Many photographers use umbrella-shaped reflectors. These are of a white or silver reflecting fabric, made especially for photographic use. But you can improvise by reflecting the light from anything that's white, fairly large and portable. You can even use a bedsheet, though holding it reasonably flat might be a problem. White cardboard will also do. You can also support a reflector with a tripod or light stand, or bring a friend along to hold it for you. You may be able to hold it yourself, although this may give you too many things to do.

AVOID DISTRACTING BACKGROUNDS

When you've positioned your subject for the best lighting, you may find that the background isn't ideal. Throwing it out of focus by using a large lens aperture can help. The simplest cure is often for the subject to sit on the ground so you can use a plain grass surface as background.

With lighting and background under control, you're free to concentrate on producing an outstanding picture. Using a tripod is a good idea because it allows you to adjust the framing carefully until it's just right, and then keep it that way.

While you're shooting, keep an eye on your camera's meter reading so you can compensate for any changes in light level. And check whether different poses call for an adjustment of the reflector's position.

EXPRESSION IS EVERYTHING

Watch the subject's expression carefully at all times. Even a small change in expression can make all the difference between a winning portrait and a mediocre one. Don't be afraid to shoot a lot of frames of each pose.

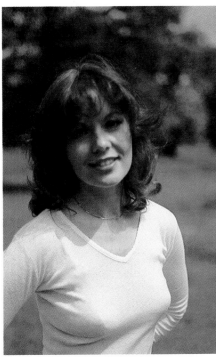

1) FILL THE FRAME
The first step in improving the snapshot on the previous page is to fill the frame better. This was achieved by moving closer to the subject. The photo was taken with a 50mm lens at a distance of 4 feet. Moving closer has thrown the background out of focus, which helps. However, a portrait made from too close up can exaggerate perspective and distort facial features.

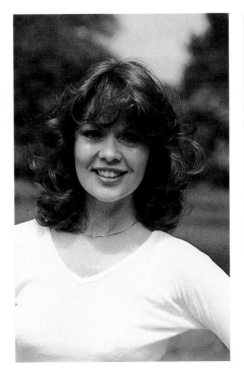

2) CHANGE LENSES
Moving back to about 8 feet gives a better perspective. A 70-150mm zoom lens was mounted on the camera. It was set to a focal length of 120mm to fill the frame. A pale-orange 81A filter on the lens warmed up the skin tones, eliminating a green color cast caused by reflections from the surrounding grass.

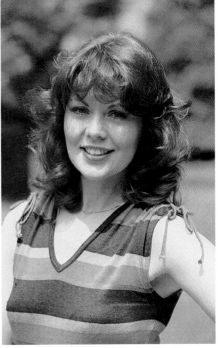

3) CHOOSE COLORFUL CLOTHING
A white blouse or shirt can be distracting because it will probably be the brightest part of the picture. A darker outfit directs the viewer's attention more to the face. The overall contrast of the scene is also reduced.

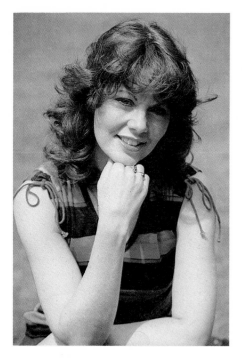

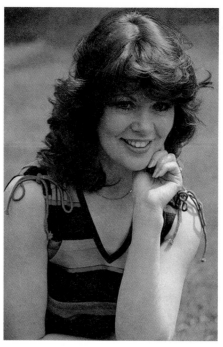

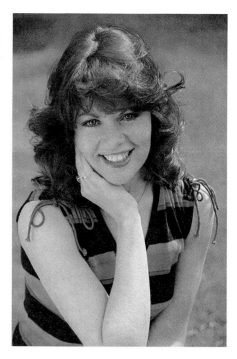

4) IMPROVE THE BACKGROUND
In the previous picture, the mixture of trees, grass and sky in the background was still distracting, even though it was now out of focus. Lowering the position of the model's head by having her sit on a tree stump provided a uniform background of grass. The sitting position enabled the model to rest her arms on her knees, so that a hand could be included in the pose.

5) HAVE SUN BEHIND SUBJECT
Getting rid of the distracting shadows on the subject's face is as simple as turning her around. Shoot with the sun behind the subject, taking care that direct sunlight does not strike the camera lens. Use a lens shield. In this study, the subject is not squinting. She looks relaxed and comfortable.

6) ADD A REFLECTOR
To brighten the face and make the illumination on it more uniform, place a white or silvered reflector in front of, and close to, the subject. When you're shooting in color, avoid reflectors that are colored. Any color in the reflector would cause an according color imbalance in the portrait.

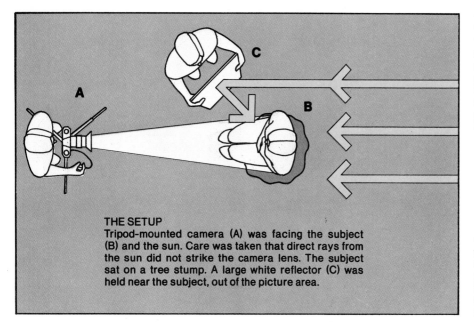

THE SETUP
Tripod-mounted camera (A) was facing the subject (B) and the sun. Care was taken that direct rays from the sun did not strike the camera lens. The subject sat on a tree stump. A large white reflector (C) was held near the subject, out of the picture area.

7) THE FINAL PORTRAIT
The photographer moved a little to the left. This eliminated the dark strip of grass at the top of the previous picture. It also gave him an attractive three-quarter view of the subject. The subject was asked to tilt her head slightly, to improve the pose further. A diffusion attachment was placed over the camera lens to give an image with softer focus.

◄ The final setup for the outdoor portrait was simple. Many objects can serve as an effective reflector. If you don't have a card, you can use a sheet, newspaper or large book very effectively. Some locations, such as beach or snow scenes, provide natural reflecting surfaces.

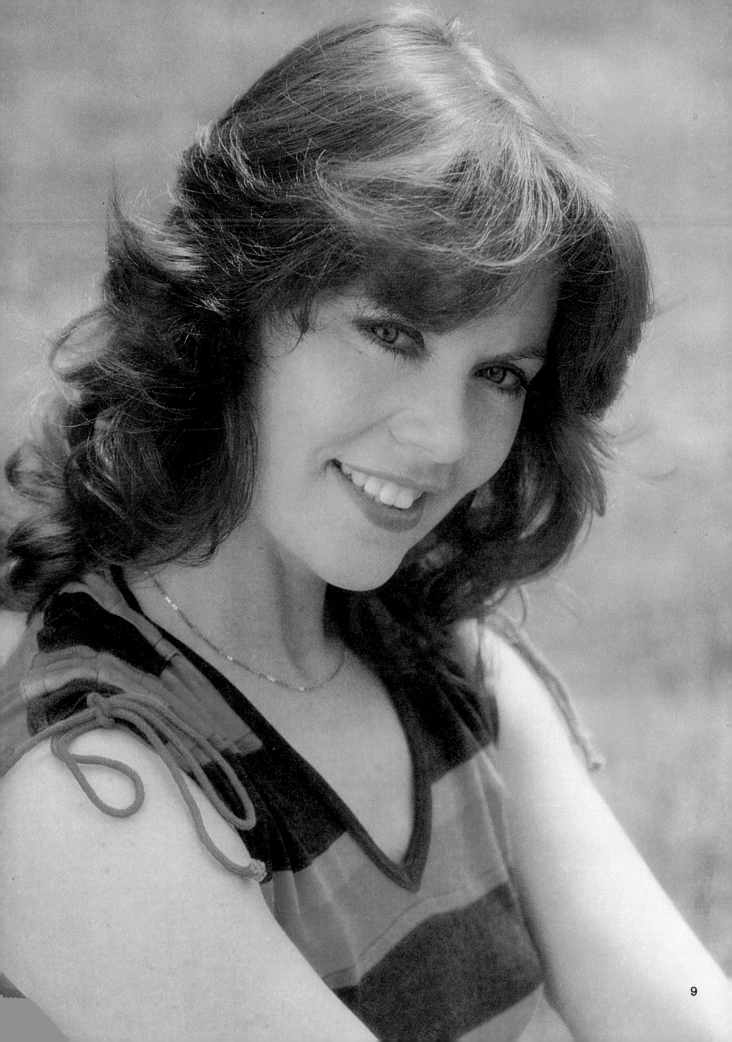

Photographing Glamour Indoors

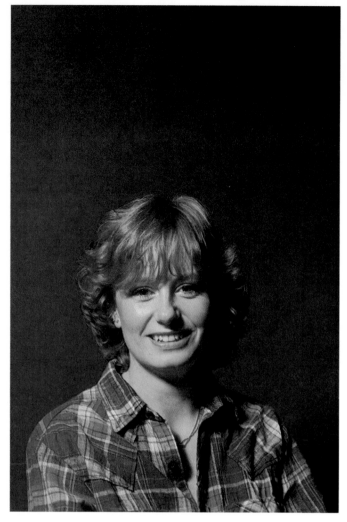

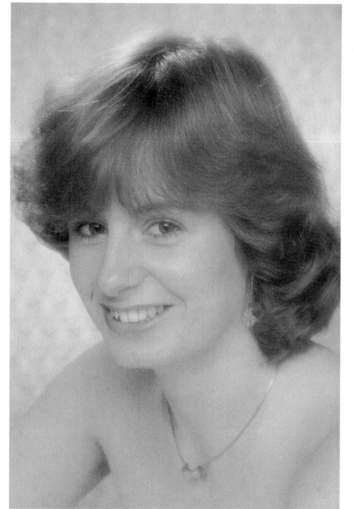

This photograph was not planned. The lighting is harsh, the hair lacks sparkle, the background is too dark, and the clothing is inappropriate for a glamour shot.

This looks more like a professional portrait. Although it was shot in a studio, the setup was simple. The portrait could easily have been taken in your home.

Professional-looking glamour portraits can be produced in an improvised home studio. You won't need lots of equipment, just an understanding of how to use a basic portrait lighting setup in a way that flatters your model.

The photo above left is nothing more than a snapshot. Although the expression is pleasant, the picture does not flatter the model. The single-flash illumination leads to hard shadows in the wrong places. The hair, which is not adequately lit, merges with the somber background. In the picture above right you can see the professional touch. The soft lighting, pastel background and soft focus, together with an appropriate expres-

sion, all add up to a glamorous mood.

The face should fill the frame. That's achieved with a zoom or tele-photo lens, not by moving in closer with a standard 50mm lens. Moving in close exaggerates perspective, leading to an unflattering effect on several facial features. Shooting with a focal length of 85mm to 135mm is best for a head-and-shoulders portrait.

The choice of clothing is important, too. The model's plaid shirt might be a good choice for an outdoor portrait, with the subject leaning against a tree, but it's not appropriate for the soft, feminine look that we want to create here.

Indoors, you'll need three lights for good lighting control.

Photofloods are hot to work under, but they offer the important advantage of letting you see how the lighting effect changes as you move each light. Except for expensive studio electronic flash with built-in modeling lights, electronic-flash units generally don't offer that ability. However, you can combine the best of both worlds by using relatively weak tungsten lights to set up your lighting and electronic flash—in the same positions—for the actual exposure.

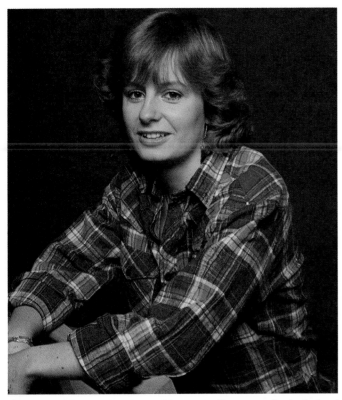

1) THE POSE. Head-and-shoulder portraits generally look best when the subject leans forward a little with one shoulder closer to the camera than the other.

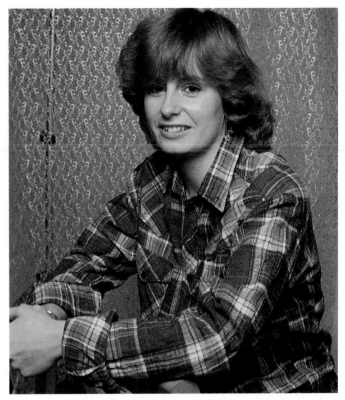

2) THE BACKGROUND. A dark background is not appropriate. To achieve a softer effect, pink netting was draped a couple of feet in front of a white paper backdrop.

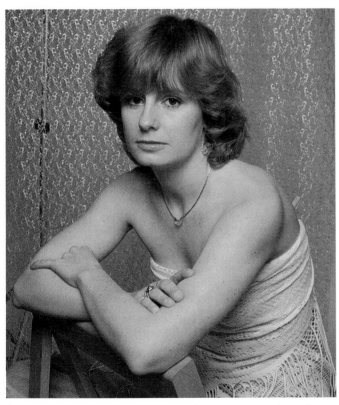

3) CLOTHING. The dark, plaid shirt isn't what we want for a glamor picture. A strapless dress that leaves the subject's shoulders bare gives a much more feminine impression.

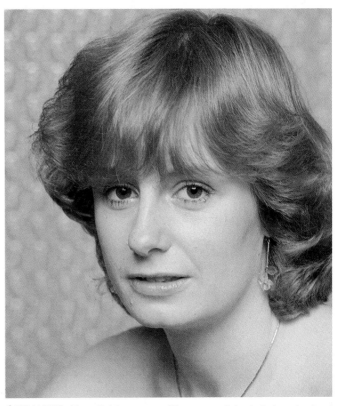

4) FRAMING. For a tighter composition, use a telephoto lens instead of moving too close to the subject. This portrait was made with a zoom lens set at a focal length of 100mm.

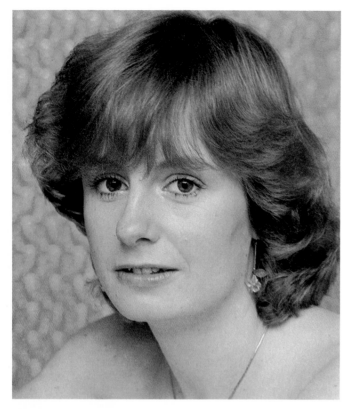

5) REFLECTORS. To soften the lighting and brighten the shadow areas, reflectors were added to the setup.

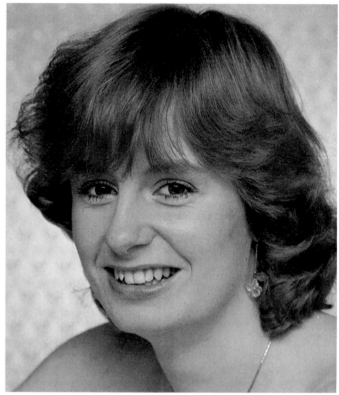

6) BACKGROUND LIGHT. A spotlight was aimed at the white background paper behind the netting. This provided a bright background, giving a halo effect around the subject's head.

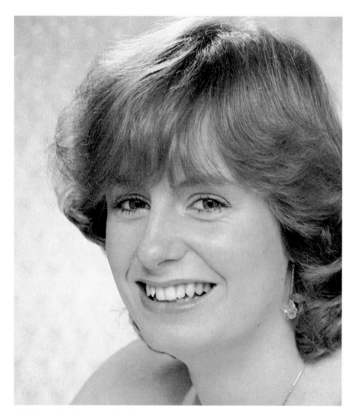

7) RIM LIGHT. A rim light was placed above and behind the subject. This added attractive highlights to the hair. This completes the lighting setup.

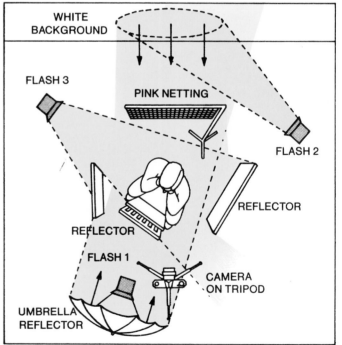

▲ This is the complete setup. Three flash heads were used: 1) The main light was in a reflector umbrella, to provide soft illumination; 2) The background light was a direct, undiffused flash; 3) The rim light gave a relatively narrow, concentrated beam of light. Lamps 2 and 3 were fired by slave units. There were three reflector cards—notice the one just below the subject's chin. It filled shadows there.

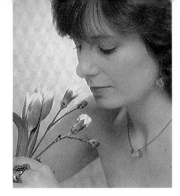

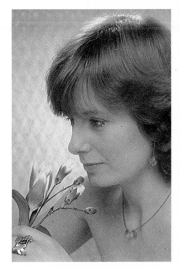

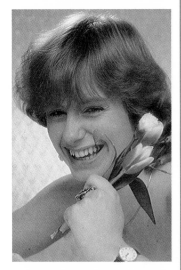

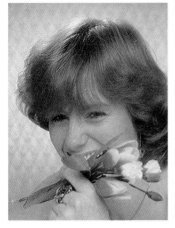

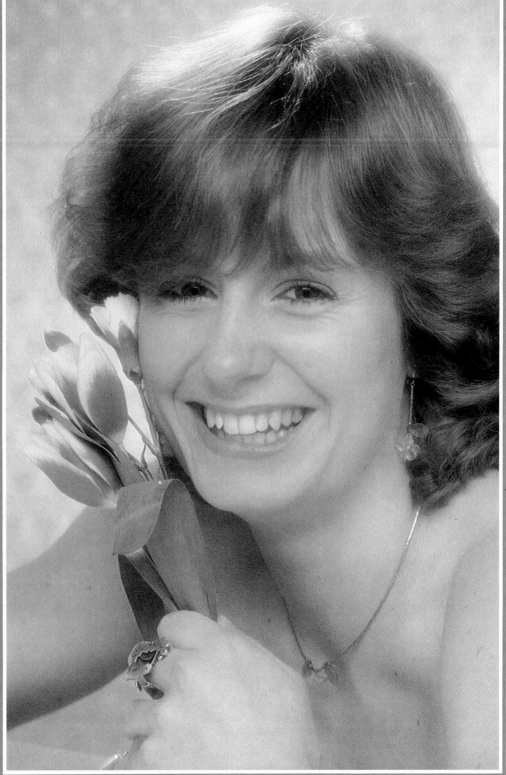

◄ Two extra touches were added. The flowers provided color and helped the composition. A soft-focus attachment on the lens softened the image. Try varying poses with your subject, look for different expressions, and shoot until you think you have the pictures you want. It's better to have many good shots to choose from than to be forced to settle for a mediocre image.

▲ A soft-focus attachment causes the highlight areas to spread slightly into the surrounding parts of the image. This gives the image softness without reducing image sharpness. Compare this portrait with the first photo on page 10. The difference between a simple snapshot and a professional portrait is obvious.

Making Character Studies

Conveying character in a portrait of an elderly man means showing the wrinkles rather than hiding them. Lighting is the secret. There's no use for soft, frontal lighting here.

SIDE LIGHTING IS ESSENTIAL

Frontal lighting provides little modeling for the face and does nothing to bring out the texture and the wrinkles characteristic of an older face. For the same reasons, avoid excessively diffused lighting. What you need is directional lighting, aimed at the subject from an oblique angle.

To understand the effect, think of a mountain scene. When the sun is behind you and shining directly at the mountains, you see a relatively flat-looking scene. You can't distinguish the hills that lie in front of the mountain or the shape of the rock formations. The scene looks two-dimensional.

When the sun moves toward the side, however, the shadows are also cast to the side, where you can see them. This enables you to see all kinds of detail. The same is true in portraiture. Move the light to the side of a weathered face, and you'll see all kinds of interesting characteristics that would have remained hidden by the light of a frontal flash.

GET A SHARP IMAGE

Sharpness is also important for showing wrinkles. Use a slow, fine-grain film and stop down your lens to *f*-8 or *f*-11 for optimum results. Because you'll use the flash close to the subject, even a modest electronic

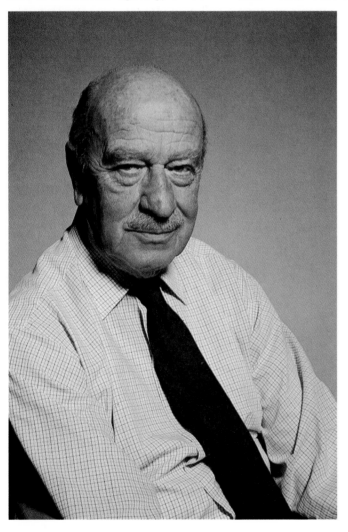

1) STARTING OUT
This is a typical flash photo. It doesn't give the effect we want. However, numerous other things in the picture need to be changed before we worry about the lighting, so let's deal with them first.

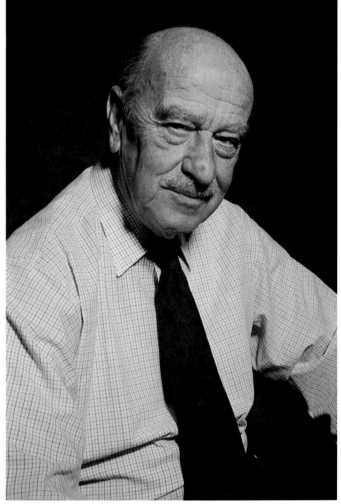

2) USE A DARK BACKGROUND
To keep the viewer's attention on the face, it's important to eliminate light-colored areas that could be distracting. For a start, switch from a light background to a dark one. This one is a sheet of dark-brown background paper, available at many camera stores. Any dark material, or a dark wall, would do just as well.

flash should allow a small lens aperture. Alternatively, you can use tungsten light such as a photoflood—but be sure to also use tungsten-type film or the appropriate color conversion filter listed in the film instruction sheet.

KEEP THE BACKGROUND DARK

To avoid distracting the viewer's attention away from the face, it's important to eliminate any large, light areas in the picture. This suggests dark clothing and a dark background. Be careful not to "spill" too much unwanted light onto the background accidentally.

The photographs on these pages were made with a professional studio-type electronic flash unit, but you can duplicate the effect with a small flash.

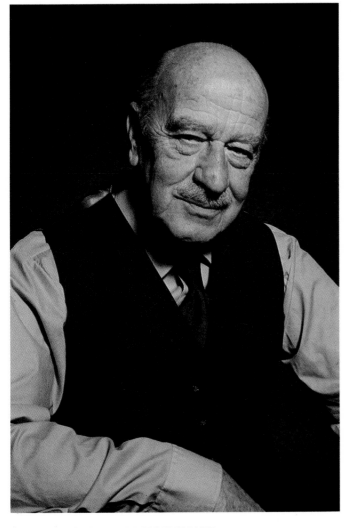

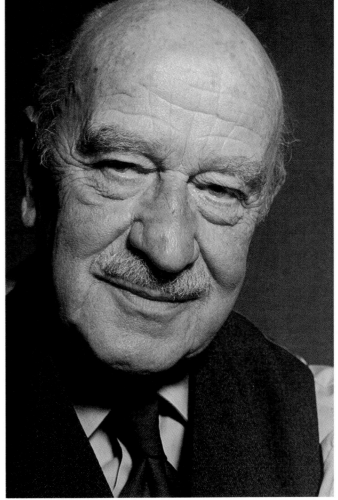

3) HAVE THE SUBJECT DRESS THE PART
Next, select darker clothing. This shirt is darker and less obtrusive than the patterned one in the previous photos. The dark vest is helpful, too. Don't choose a shirt that's too dark, or the portrait might wind up looking like a disembodied head.

Even though we're still using front lighting, which is not the best choice, changing the background and clothing have greatly improved the picture already.

4) FRAME TIGHTLY
A character portrait is more forceful if the size of the head is large. To avoid the distortion that would result from moving in too close to your subject, use a telephoto lens of 85mm to 135mm focal length. Here a 70-120mm zoom lens was set at about 100mm for a tight head-and-shoulders crop. Now we can direct our attention to the lighting.

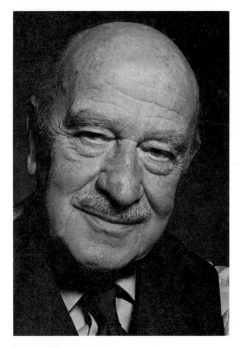
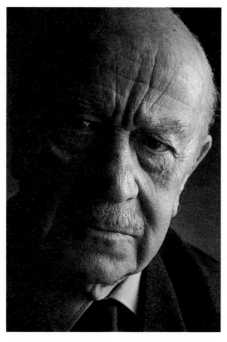
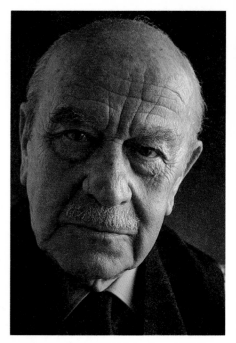

5) FRONT LIGHTING
The first four pictures were all made with the same kind of illumination—front lighting. To enable you to easily compare this unsuitable kind of lighting with the side lighting we're going to develop next, we've reproduced a front-lit portrait here. Although you can see some of the wrinkles in the face, they are not as dramatically accentuated as in the following photos, nor is the skin texture as evident.

6) USE SIDE LIGHTING
Let's switch to side lighting that will accentuate the subject's character lines. We'll use an extension cord on the flash so we can move it around to the side, as shown in the diagram below. We'll also soften the light just a little, to avoid an excessively harsh effect, by adding a translucent diffusing screen. Photo dealers sell them, or you can make one from a piece of tracing paper or similar material. Diffusers vary, but generally you'll need to open up the lens aperture about one f-stop to compensate for light absorption and scattering.

7) ADD A REFLECTOR
Even with the diffusing screen, the shadow side of the face is dark and reveals no detail. A white plastic reflector board bounces enough light into the shadows to reveal some detail without compromising the strong modeling of the face. You can also use white cardboard as a reflector, or any other material that's white and can be mounted conveniently. The diagram below shows the final lighting arrangement.

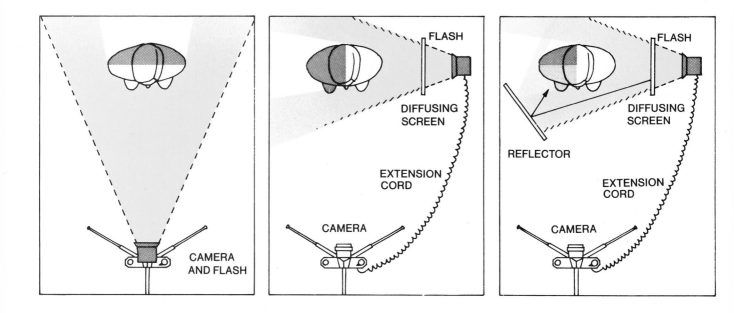

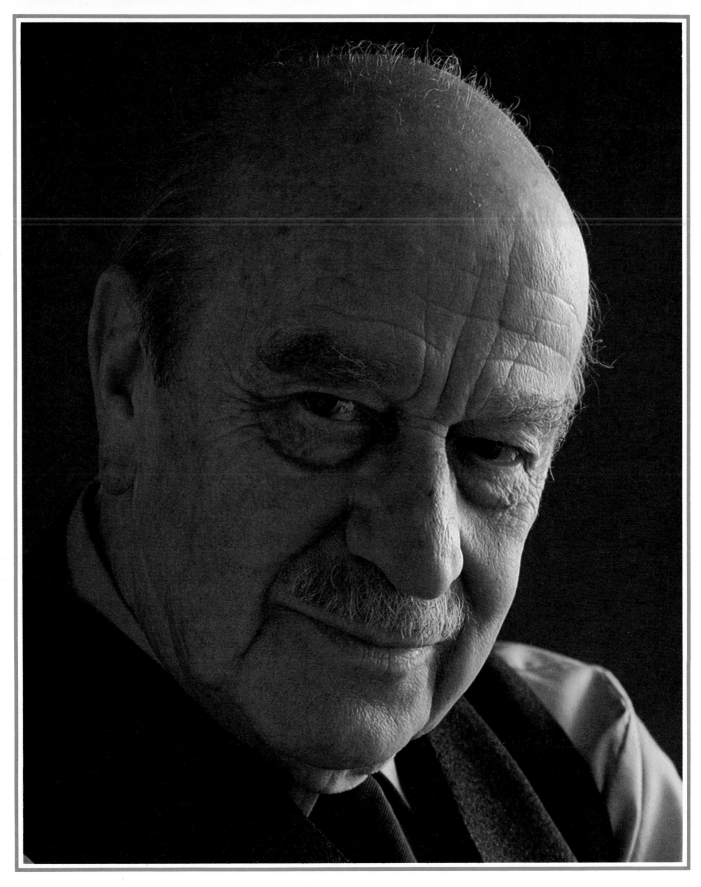

8) FINE-TUNE THE POSE

To improve the pose, the photographer asked the subject to turn his head slightly to his left. This three-quarter angle is a favorite of professional portrait photographers. Note that the subject has maintained eye contact with the camera. This is a good character study—the expression is right, skin detail is excellent, and there is adequate detail in the shadows. Also, the dark background and clothing keep the viewer's attention on the face.

Candid Photography

You'll often find that your subjects freeze up when they know they're being photographed. They stand there stiffly, waiting for the shutter to click, and look as though they were waiting for a firing squad. All they can manage is a feeble grin, when what you want is a big smile. Here are some tips for taking candid pictures that'll make even these people look natural.

GIVE THEM SOMETHING TO DO

Most important, find something to occupy your subject's mind. For example, in the situation pictured here, the more the subject is thinking about what to buy in the public market, the less thought she'll give to you and your camera. If you put people in a situation they're genuinely interested in, they'll relax and look natural.

For people who aren't too self-conscious, working on a hobby or reading a book may be enough distraction to let them relax and forget about the camera. If you're photographing people who really freeze when they hear the shutter click, however, you'll be better off in a public place where you can "hide."

The public market setting used for our example is such a place. Fresh fruits and vegetables are interesting to everyone, and the color and variety of the market environment provides excellent subject matter and background.

A ZOOM LENS IS HANDY

You'll want to match the lens you use to the circumstances. If your subject is really involved, or not too shy to begin with, you can work fairly

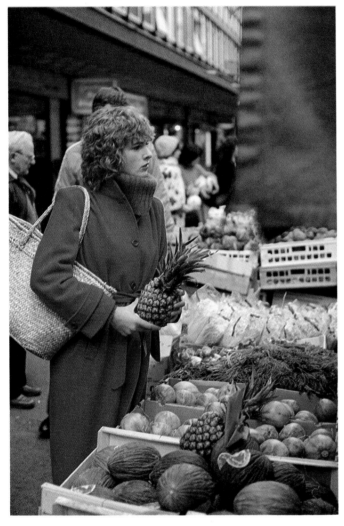

DISTRACTING BACKGROUND
When you're looking through the viewfinder and concentrating on your subject, it's easy to forget that the background can be a problem. That's especially true if you're shooting at a small aperture with extensive depth of field. Unless you use depth-of-field preview, you'll view the scene with the aperture wide open. The fuzzy background you see at ƒ-2.8 or ƒ-4 will become sharp enough to be intrusive at ƒ-8 or ƒ-11. Both the building and the canvas stall are distracting here. The photographer should have avoided them, and the man directly behind the subject.

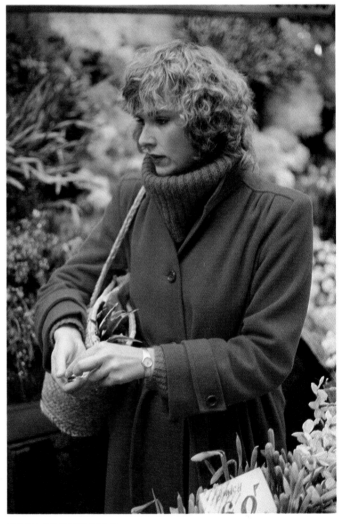

GOOD BACKGROUND
Moving in closer and opening the lens to its maximum ƒ-1.4 aperture put the background out of focus. The colorful blur of the flowers enhances the picture. This soft, warm-toned backdrop combines harmoniously with the subject, rather than detracting from it. Don't be afraid to use your lens wide open to get this effect; just focus carefully on your main subject.

close and shoot with a standard lens or maybe even a moderate wide-angle like a 35mm. More likely, you'll want to stay farther away and keep a large image using a moderate telephoto—a focal length from about 85mm to 135mm—or a zoom that covers the same range. The location may put you in cramped quarters where it's hard to reach just the right vantage point, so the flexibility of a zoom lens could save the day.

USE A FAST FILM

Your choice of film depends on the lighting. Remember that markets often have covered areas as well as open-air stalls. A fast film, such as ISO 400/27°, gives you the flexibility of shooting in both lighting conditions without problems. The extra speed is also a help with a zoom lens, which probably doesn't open up wider than f-3.5 or f-4.

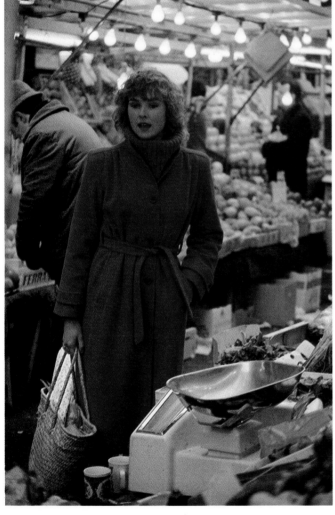

ZOOMING—75mm
A longer-than-normal focal length helps you remain inconspicuous, and a zoom lens gives you great freedom to compose different shots without moving. Shooting from about 20 feet away with the lens set at 75mm, the photographer was again faced with the problem of a busy, distracting background. The lens is wide open—at f-3.5—but there's still too much depth of field.

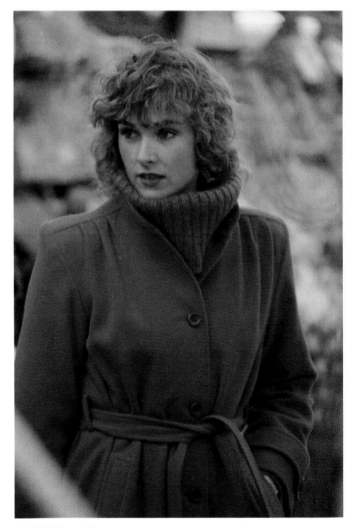

ZOOMING—150mm
The picture was improved immensely just by moving the zoom setting to 150mm. Without changing his position, the photographer filled the frame with his subject. He also subdued the background, because depth of field is much less at the 150mm lens setting. This is now a very attractive candid portrait. And, because the photographer was 20 feet away, it's unlikely that even a shy subject would have been aware that this picture was being taken.

► SHOOT FIRST . . .

While you're out shooting, chances are you'll come across some interesting interactions between your subject and other people. Be ready to grab a picture with an intriguing gesture or facial expression. With a standard lens, preset the focus to an appropriate distance—say, 10 to 15 feet—and set the exposure, then keep your eyes open. If your camera offers fully-automatic exposure control, so much the better. When you spot something interesting, just aim and shoot. After getting the first shot, you can fine-tune focus and composition for another picture, if there's time.

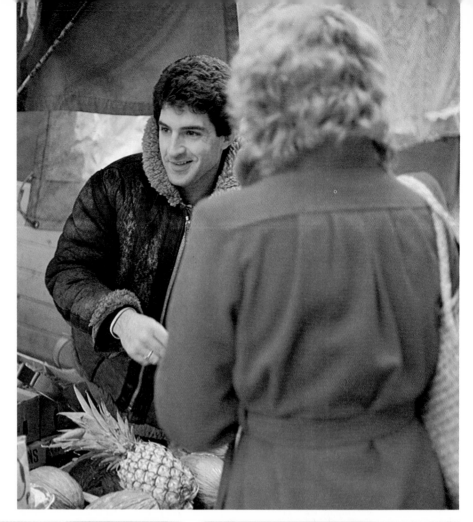

▼ . . . THEN FOCUS AND COMPOSE

After taking the "grab shot," the photographer moved to the right until he could see both faces. This angle also shows more clearly that the location is a public market. Depth of field is limited, but both people are in focus because they're both about the same distance from the camera.

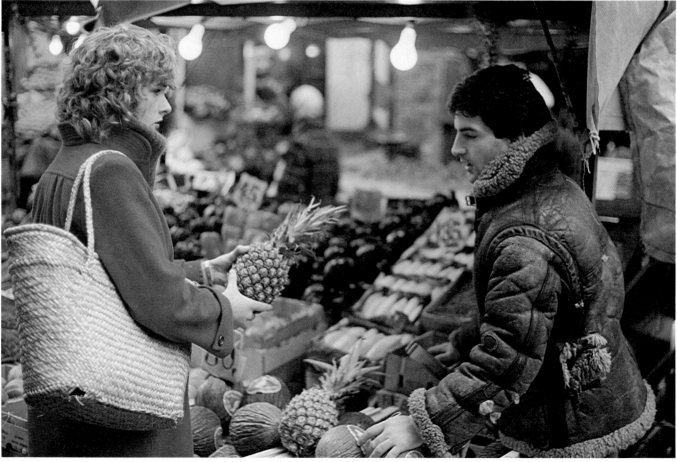

20

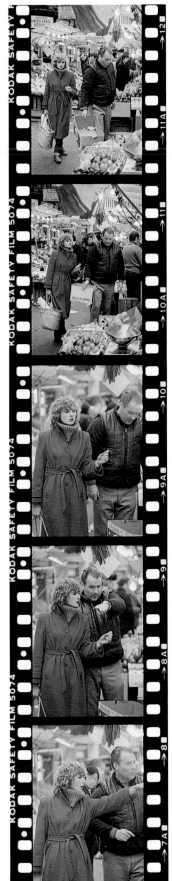

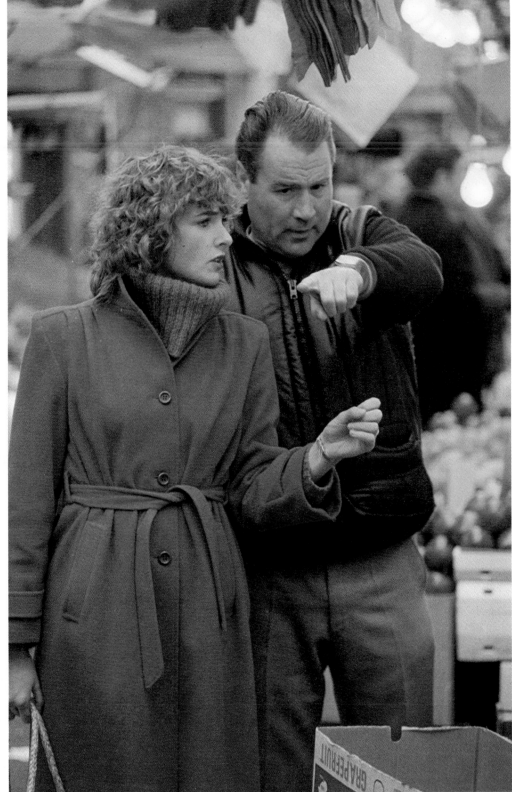

◀ SHOOT LOTS OF FILM

Even though your subject knows that you're taking pictures, candids aren't nearly as controllable as formal portraits. Shoot as much film as you think is necessary to get the shot you want.

▲ SELECT YOUR FAVORITE PICTURE

Shooting generously gives you the luxury of a big selection after the film's been processed. When you've chosen the one or two you like best, you can have enlargements made.

Faraway Candids

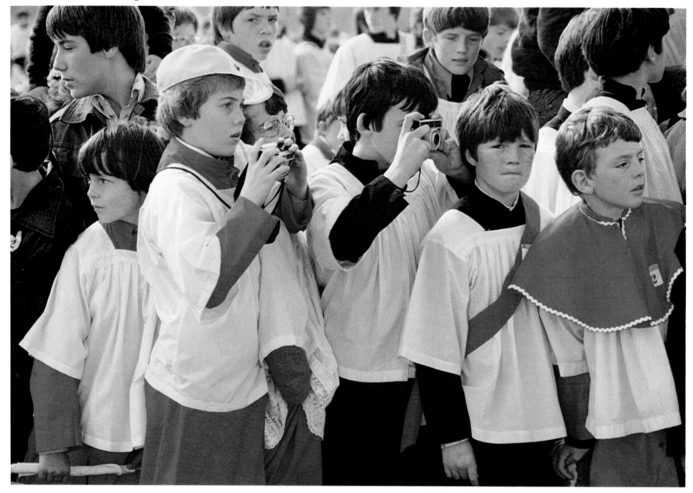

We are all fascinated by people and their varied behavior, but many of us hesitate to photograph strangers. A telephoto lens can be a great help.

There are many differences between amateur and professional photographers. A significant one is this: Professionals constantly take pictures of complete strangers. Whether they're shooting for a newspaper or magazine, or building up their files or stock photos for future sale, professionals are constantly looking for interesting people pictures.

There's no way to guarantee people's reactions if they notice you've taken their picture. You can minimize the chance they'll notice you in the first place simply by keeping your distance and using a telephoto lens. Either a fixed focal length or a zoom is fine. Fixed-focal-length lenses are generally lighter and more compact; zooms offer greater flexibility in framing your subject.

TWO APPROACHES

You can choose two different approaches to candid photography. The first way is walking around, looking for subjects, being ready to shoot at a moment's notice. The second method is one that not many amateurs use. Find a promising location, such as an open-air cafe, a telephone booth or a newspaper stand, set up your camera on a tripod, and wait for an interesting situation to arise. This calls for a lot of patience.

You'll be much less conspicuous if there are crowds of people than if the place is deserted. There's not much you can do about that except pick locations where there are lots of people to start with. Using a long cable release can be a help, because it lets you move around and trip the shutter without touching the camera itself. An autowinder adds the ability to take a whole roll of film without handling the camera directly.

▲ As people have become more and more accustomed to seeing cameras, candid photography has become easier. When the people you are photographing have cameras themselves, and are concentrating on getting their picture, it makes it even easier for you. These choir boys were photographed while they were eagerly awaiting the arrival of the Pope.

SHOOT THE AUDIENCE

Photographing in a resort town or tourist center helps make you invisible because almost everyone there has a camera. In a situation like this, you can achieve two objectives at the same time. For example, you can get pictures of Mickey Mouse at Disneyland, then turn around and take some great candids of wide-eyed kids seeing their favorite cartoon character "in the flesh."

If you're in a situation where there just aren't many people and you stick

ROVING CAMERA

One way to take candid shots with a long lens is to be mobile. Move about, and be ready for any interesting situation that presents itself. For handheld operation, don't try too long a lens. A 200mm or 300mm lens is the upper limit for most people, or a zoom that reaches that range. Use the fastest shutter speed you can, and consider a fast film even for outdoor shots. Outdoors, you should be able to use a shutter speed of 1/500 second. Prefocus, if possible, using something at the same distance as your subject but off to one side. Then swing around and quickly take your picture.

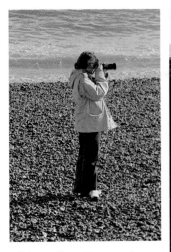

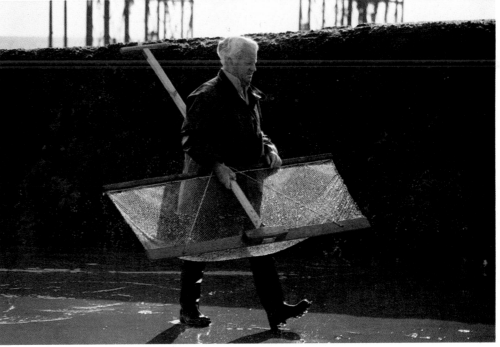

John Garrett used an 80-200mm zoom lens set at 200mm to take this backlit picture of a man collecting shrimp at low tide. A 1/500-second shutter speed helped prevent camera or subject movement.

FIXED CAMERA

Other candid pictures can be the result of advance planning. You set up the camera and tripod, aimed at a likely spot such as this bench in a shopping area. After aiming and setting exposure and focus, you don't have to look through the camera viewfinder. You can look directly at the scene. A long cable release even allows you to stand a little away from the camera, as if you weren't taking pictures at all.

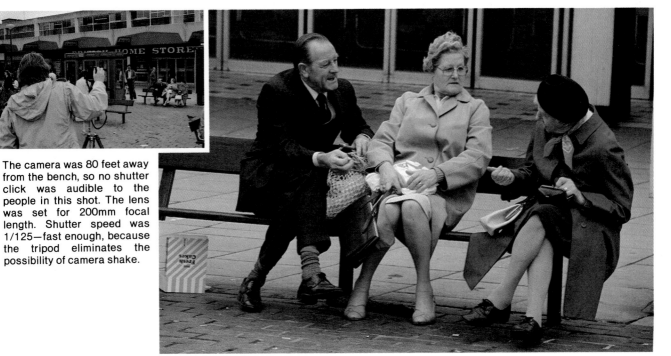

The camera was 80 feet away from the bench, so no shutter click was audible to the people in this shot. The lens was set for 200mm focal length. Shutter speed was 1/125—fast enough, because the tripod eliminates the possibility of camera shake.

out like a sore thumb, such as on a beach on a cool, cloudy day, don't give up in despair. Go over and talk to your subjects. Show that you're interested in what they are doing. You'll find that most people love to talk about themselves. After you chat for a while, they probably won't mind you taking their pictures. They'll likely go back to whatever they're doing and practically forget you're even there—which gives you the opportunity for taking some really natural people pictures.

MAKE FRIENDS USING INSTANT PICTURES

You'll have to work out your own way of dealing with the crowds of kids who sometimes materialize around a photographer, calling out, "Hey, take my picture!" They mean well, but it's hard to be inconspicuous when you're surrounded by an entire grade school. An instant camera can bail you out of this situation, but be prepared to shoot the whole pack of film.

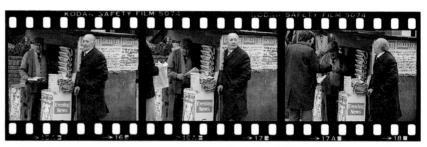

Small changes in people's expressions and positions may enable you to produce only one winner in a whole series of shots. After setting up the camera to photograph this newsstand, the photographer made ten exposures. Three are shown here, and the best frame is enlarged.

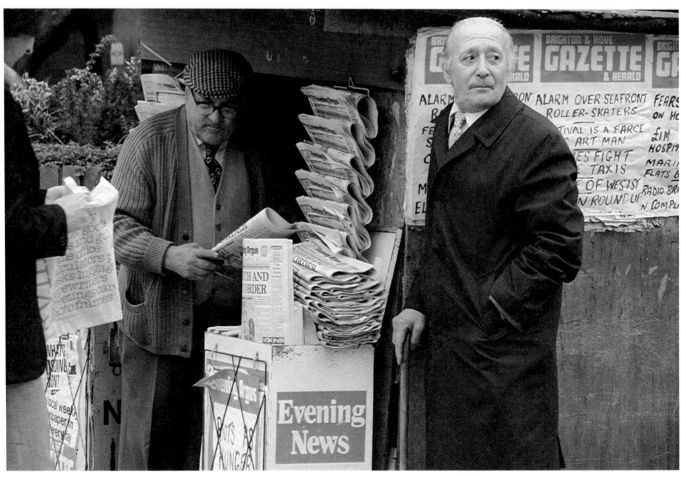

A telephoto enables you to get pictures like these from 50 feet away, although in this case the subjects probably wouldn't have noticed a photographer even if he had been next to them. A zoom lens enables you to frame selectively without changing camera position.

Sometimes you can get excellent pictures of people who know you're photographing them. The seated couple, the baby in the stroller, and even the boy in the background, all know they're being photographed. This adds to the charm of the picture.

Flowers Close-Up

The next time you see a magnificent close-up photo of a flower, pause to reflect that it may have been photographed in a wind-free and air-conditioned studio with controlled, professional lighting. Knowing this might make you feel better when you're doing your best to focus on a beautiful rose, while crouched down over the rose bush on a hot, windy summer afternoon.

That isn't to say you can't make top-notch flower pictures in a garden. But you'll find it's a lot easier if you know how the professionals approach the problems.

FIND THE RIGHT FLOWER

The first step is finding the right flower, of course. A bloom that looks gorgeous from several feet away may turn out to have nicks and blemishes when you get really close. Flower photographers routinely brush away dirt and pollen, trim off wilted leaves, and even clip a few perfect leaves from a neighboring plant. Your goal is to make the flower or plant look its very best.

YOU NEED CLOSE-UP EQUIPMENT

For close-up work you need exten-sion tubes or bellows, or a close-up attachment lens. Or, you have to switch to a macro lens designed for close-up work. A macro lens is expensive but convenient. With it you can photograph the whole garden and then a close-up of a single plant with just a twist of the focusing ring. If a macro lens is beyond your means, don't give up. You can get fine pictures with an accessory close-up lens that costs no more than what you'll pay for two or three rolls of film.

A PLAIN BACKGROUND HELPS

A simple piece of cardboard gives

1) THE OPENING SHOT
This photograph shows the typical problems most of us have when photographing flowers. Using a standard lens without any kind of close-up attachment, it's possible to get within about 1-1/2 or 2 feet from the subject. At this distance, the blooms look very small and there's too much unwanted background. Also, there was enough wind to move the flowers during the 1/60-second exposure, causing a blurred image.

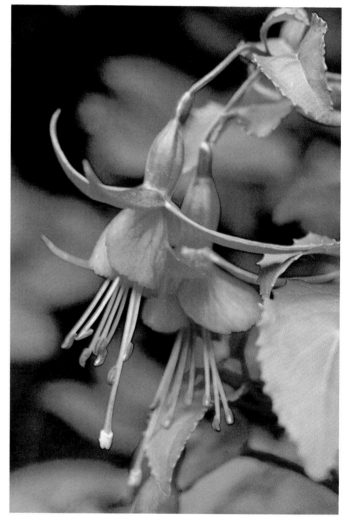

2) SWITCH TO MACRO
Moving in very close with a macro lens improved the picture significantly. The lens filled the 35mm frame with a subject area as small as 2x3 inches. The image on film is about half life-size. Of course, enlargements and projected slides show images far larger than life-size.

you a plain backdrop that hides all the untidiness that may exist behind the bloom you are aiming at. If a cardboard backdrop isn't to your taste, shoot with a large lens aperture, to throw the background completely out of focus. There's so little depth of field in the close-up range that this shouldn't be hard to do.

Keeping flowers from moving while you shoot requires a windless day, a cardboard wind-shield next to the plant, or securing the plant in some way to prevent it from moving. Or, easiest of all, work with a potted plant you can bring indoors.

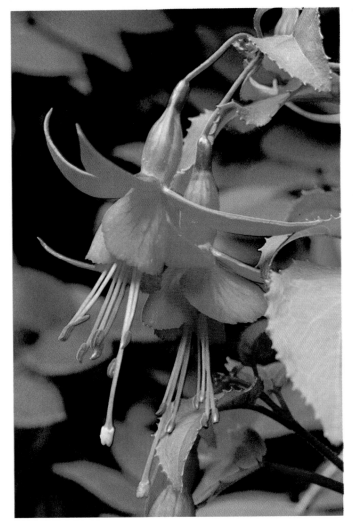 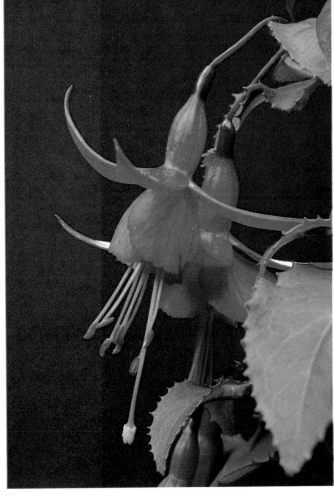

3) STOP MOVEMENT
A large cardboard wind-shield placed next to the plant shelters it from the wind, making sharp pictures possible even at 1/4 second on a slightly windy day. The longer exposure time allowed stopping down the lens for more depth of field. Naturally, the camera was mounted on a tripod for the 1/4-second exposure.

4) IMPROVE THE BACKGROUND
One advantage of close-up photography is that a relatively small piece of cardboard can hide the entire distracting background of out-of-focus leaves and plants. Choose a dark shade that will make the bloom stand out, like this dark gray card.

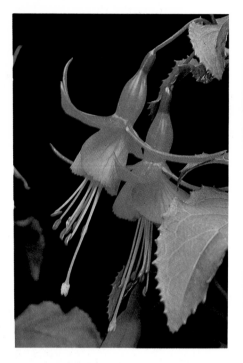
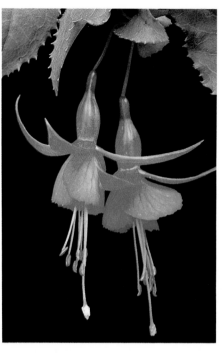
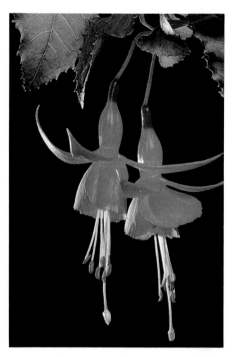

5) MOVE INDOORS

For the best control of the environment, bring the plant indoors. An indoor setup, even if improvised, is much easier to work with than an outdoor garden. This shot was lit by a single electronic flash to simulate the daylight conditions in the previous picture. Notice that the dark background card is still being used.

6) REARRANGE THE FLOWERS

To get the desired composition, the photographer took some liberties with nature. He cut a couple of blooms and some leaves from the plant and clamped them together the way he wanted them. Of course, care must be taken that the clamps or other fastening devices are excluded from the picture area.

7) ADD A BACKLIGHT

Placing a second flash unit to the side and behind the flowers adds glistening highlights to the picture. To prevent flare, care must be taken that no stray light is permitted to strike the camera lens. In this setup, a piece of cardboard was used to shield the lens. The effect of the backlight can be varied by changing the distance between the lamp and the flower.

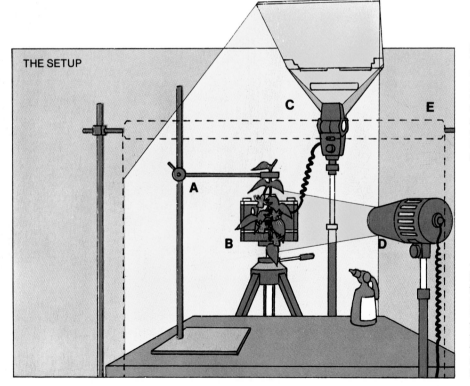

THE SETUP

8) THE FINAL RESULT

Two extra touches yielded this final picture, certainly an outstanding example of floral photography. First, the plant was misted with a small houseplant sprayer. This gives the effect of a plant glistening with morning dew. Second, a cross-star lens attachment was placed on the lens, picking up highlights and converting them to four-pointed star patterns.

◀ Looking toward the camera from the background, you can see how the plant was firmly held in place by the clamp (A). It was placed about 10 inches from the camera (B). The lighting was diffused by using a white card (C) to bounce the light from the flash unit. Backlighting on the plant came from a flash unit with a snoot (D). A roll of black background paper (E) is represented by the broken line.

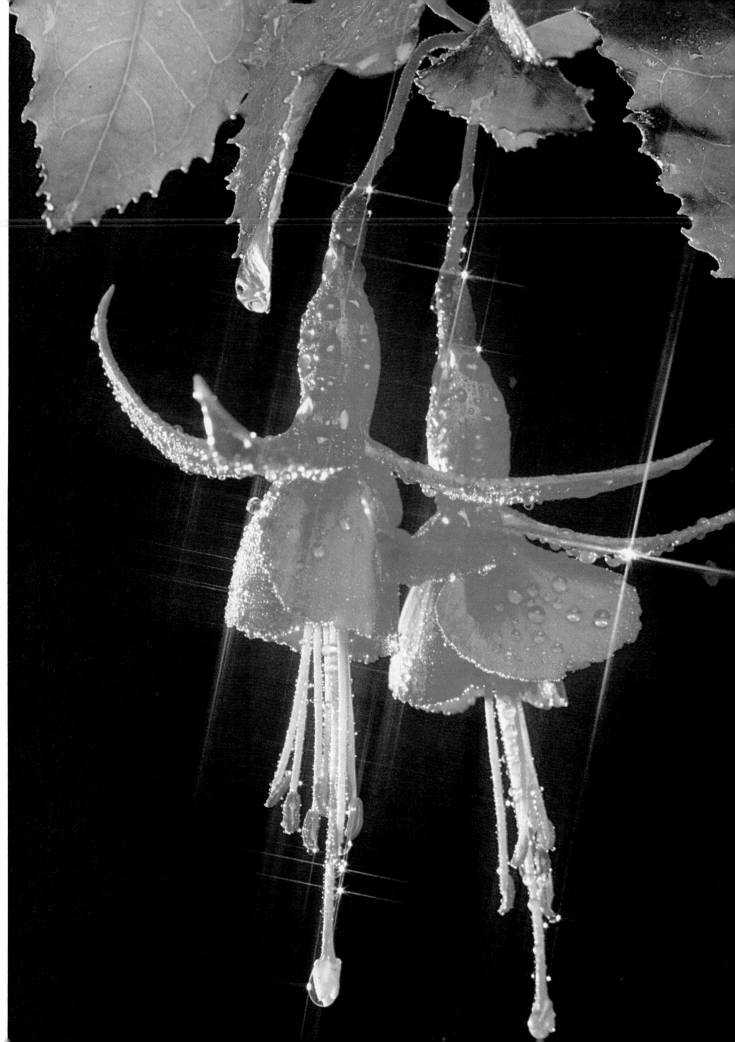

Night Photography

There's almost unlimited scope for photography after daylight hours, especially in a large city. Street lighting, illuminated advertising signs, floodlighting and even the lights of moving traffic all offer exciting possibilities to the imaginative photographer.

In the case illustrated here, the aim was to capture the vitality of the city at night. The method was to record the streaks of light caused by moving traffic, as the traffic came and went through a floodlit arch. To record the car lights as streaks, a long exposure time was necessary.

PREPARATION

A suitable location was found during the day. Not only was an attractive arch needed, but the photographer had to find out whether the arch was floodlit at night. The street approaching the arch had to be wide and straight. Also, there should be no intersections or traffic lights between the arch and the photographer's viewpoint.

When the photographer found the location, the first problem became evident: Where was he going to stand with his camera? The logical place was the middle of the street—logical perhaps, but not necessarily safe, especially at night. The solution was a traffic island. He set up his tripod on one of these.

SELECTING LENS AND FILM

Because traffic islands on this particular street are few and far between, the location determined the necessary lens focal length. The photographer was far from the arch, and a lens of long focal length was called for.

A 300mm telephoto lens framed the scene nicely. The long lens had an additional advantage. It kept the divergence of the two parallel traffic lanes to a minimum, and thus avoided an unacceptably large black area between the two lanes.

Kodachrome 64 film was chosen because the photographer felt it gives better color than Ektachrome at long

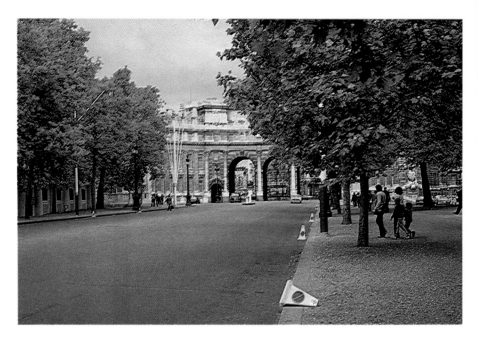

1) GETTING SET
The first experimental shots were made in daylight. A 50mm lens was used and the picture was taken from the side of the street. The arch appears too small and is partly obscured by foliage. In the final photo, the arch must be given a prominent and central place in the picture.

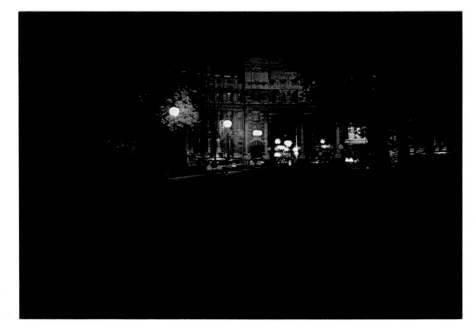

2) TRYING IN THE DARK
The first picture made in darkness was taken with the camera set for automatic exposure. A 50mm lens was used and the aperture set to its widest setting of *f*-1.4. The exposure time on Kodachrome 64 was 1/15 second. The arch looks a little dark. However, this first shot gave the photographer some idea of the correct exposure for the final picture.

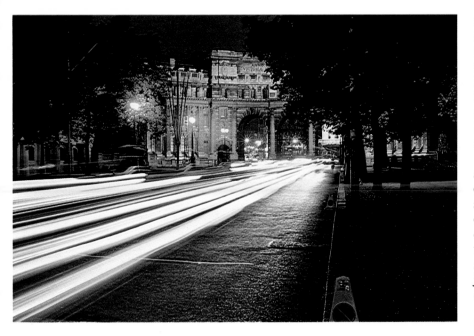

3) STREAKING THE CAR LIGHTS
The cars in the previous picture are almost sharp. To get the lights to streak, a much longer exposure time was necessary. A close-up meter reading was made of the arch. It indicated an exposure of 1/8 second at *f*-1.4. For an exposure time of 2 seconds, the photographer stopped the lens down to *f*-5.6. Because of the effect of low-light level reciprocity failure on the film, more exposure was needed to prevent underexposure. An initial exposure time of 4 seconds was used. It was evident that a tripod would be needed to hold the camera still.

exposure times. Kodak recommends a 10CC red correction filter for long exposure times with Kodachrome 64, to overcome a bluish-green cast. However, this recommendation was ignored because the inherent reddish quality of the floodlighting and the car lights provided the necessary compensation.

The camera was set on a heavy, sturdy tripod. This was necessary because the movement of traffic on both sides of the camera during a long exposure time caused a threat of unacceptable camera vibration. The arch was to be recorded sharply, with the streaks of car lights smooth and not jagged—so total camera stability was essential.

LIGHTS! ACTION!
As soon as it was dark enough for the floodlighting to be switched on, the work could begin. This happily coincided with the heavy flow of evening traffic. Many pictures were taken.

The photographer varied the exposure time, changed the lens aperture, and even changed lenses once for a different effect. The most effective result, shot with the 300mm lens, is reproduced on page 33. Exposure was for 16 seconds at *f*-5.6.

RECIPROCITY FAILURE
At low light levels, reciprocity failure can lower the effective speed of the film, leading to underexposure. Film manufacturers provide information on the reciprocity characteristics of their films and what exposure and filtration compensation is required. When you are in doubt, bracket exposures toward overexposure by one, two and three exposure steps.

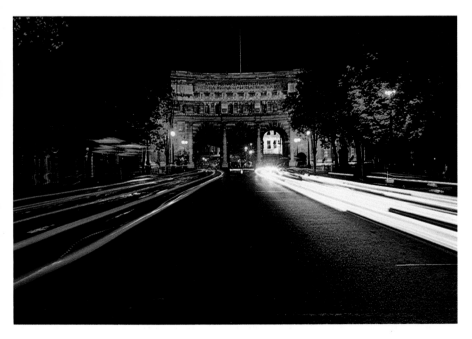

4) MOVING TO THE STREET CENTER
This photo was taken from the same distance as the previous ones, but the photographer had moved to a traffic island in the center of the street. The streaks of the car lights, both coming and going, are now clearly visible. The composition is symmetrical and much stronger—the arch in the middle and the streaks going off equally in both directions. The 50mm lens was still being used. Exposure was the same as in the previous picture.

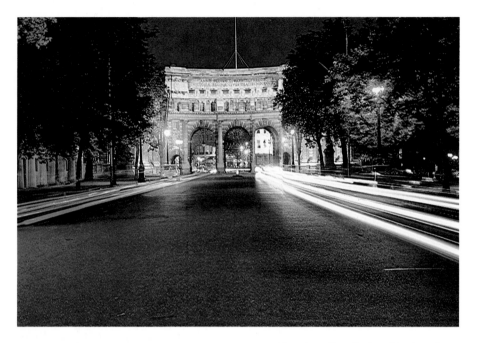

5) INCREASING EXPOSURE

To make the arch brighter and to add detail to the trees, the exposure time was increased. Bracketed exposures of 4, 8, 16 and 32 seconds were made at *f*-5.6. This photo was made at an exposure time of 16 seconds. The only really satisfactory way of ensuring a good exposure in a situation such as this is to bracket exposures. Be-cause of reciprocity effect, subject contrast and the specific effect wanted, there is no sure way of getting best results on the first try.

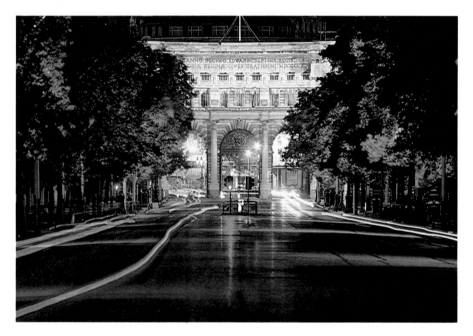

6) USING A TELEPHOTO

In the top photo, the arch is still too small. The photographer can't move closer without leaving the island and stepping into the traffic. A relatively short telephoto lens framed the picture in the desired way, but the perspective was not right. The photographer felt that the longer the lens, the better the final picture would be. So he chose the 300mm lens. This required that he move farther away, to another traffic island. His original location is now visible in the picture. Exposure was 16 seconds at *f*-5.6.

7) THE FINAL PICTURE
The previous photo does not contain enough car-light trails. With the 300mm lens, it's important to look through the viewfinder and become totally familiar with the area of the scene that will actually be recorded on film. When that area contains cars, make the exposure. For this photo, the film was exposed only when traffic was flowing. The rest of the time, the lens was covered with a black card. Total exposure time was about 16 seconds at *f*-5.6.

Action Outdoors

Capturing action in a still photograph may sound contradictory. It's true that you won't see people running and jumping as you do in a movie. But you can still use a lot of tricks in still photography to simulate action and motion.

The pictures in this section were made at a sports arena. But you can do the same sort of thing at a local school or club—any place where athletes train and compete. Select an athlete, and discuss with him what you plan to do. If you indicate that you do not intend to interfere or hinder his activities, you have a good chance of getting the cooperation you want.

Hurdling, the subject of this section, is a suitable activity for the beginner in action photography. The interesting part of the activity nearly always occurs at a hurdle—so you know in advance where to focus, and where the peak action will be.

FAST SHUTTER SPEEDS AND LONG LENSES

Sports activities don't always take place in bright sunshine. Sometimes, dim light may be a problem, especially when you're shooting color. If you want to *freeze* action—avoid all image blur—you'll generally need a shutter speed of 1/500 second or faster. To enable you to shoot at such shutter speeds, you may have to use a fast film, push-process film, use a fast lens

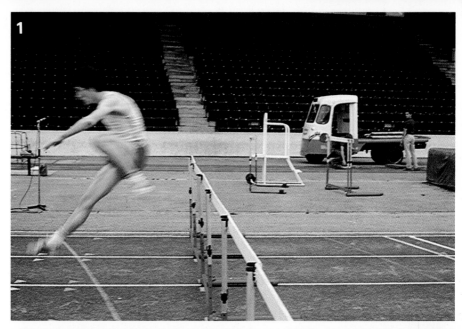

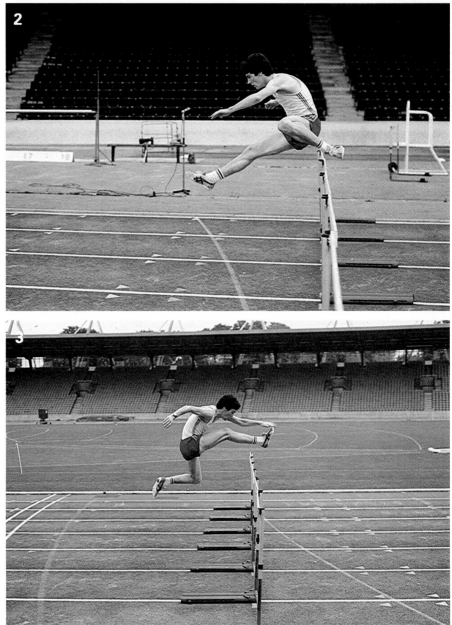

1) THE FIRST TRY
This exposure was made too late—the interesting peak action has passed and the hurdler is almost out of the picture. The shutter speed of 1/60 second was not fast enough to *freeze* the action. A 50mm lens was used.

2) FREEZING THE ACTION
The image of the hurdler is now much sharper because the shutter speed was increased to 1/500 second. The hurdler was caught almost at the peak of the action, but not quite. The background is still distracting.

3) IMPROVING THE BACKGROUND
To get a less distracting background, the photographer moved to the other side of the track, still using a 50mm lens. Exposure was 1/500 second at *f*-2.8. The hurdler has been caught at the peak of his leap.

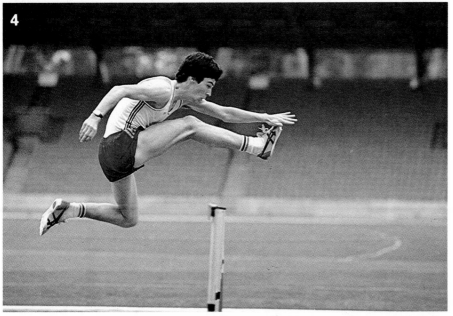

4) CHANGING TO A TELEPHOTO
With the standard lens, the hurdler didn't occupy enough of the image area. Here, a 135mm lens was used. Exposure was still 1/500 second at *f*-2.8. The background is now less sharp and less distracting. The photographer crouched down for a lower viewpoint, to make the leap appear higher and more dramatic.

5) PANNING WITH THE SUBJECT
The previous photo does not give a feeling of speed because the image of the hurdler is sharp. It needs to be blurred, although not as much as in the first picture. A shutter speed of 1/60 second was used and the camera was panned. The hurdler is slightly blurred, and the background more so—giving the impression of speed and action.

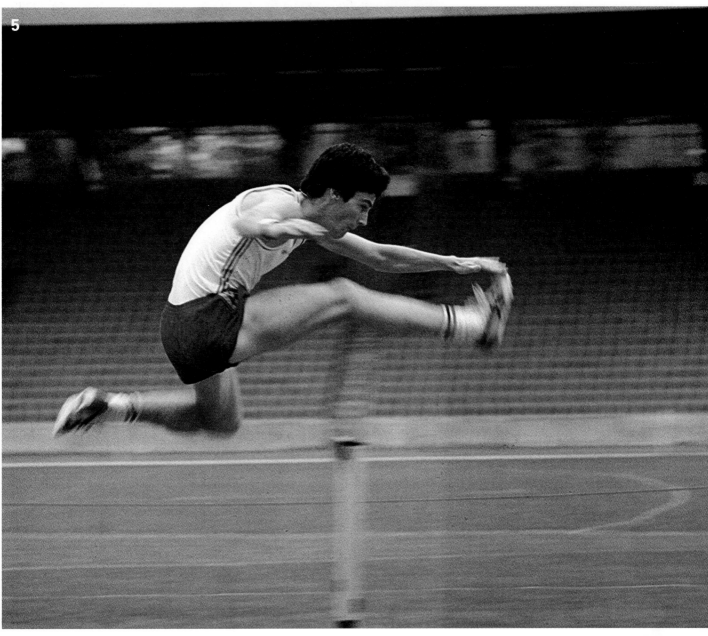

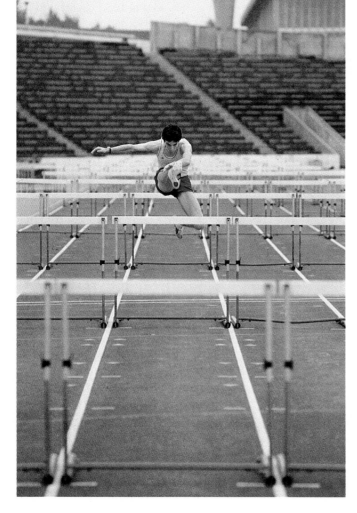

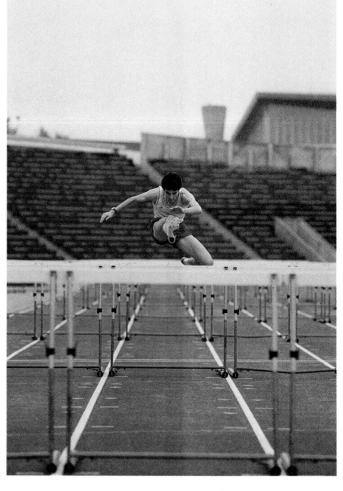

SHOOTING FROM THE FRONT
An effective photograph can be made by looking down the track and making the exposure as the hurdler comes toward you. This photo was made from just beyond the finishing line, with a 135mm lens. Exposure was 1/500 second at *f*-2.8.

LOWER VIEWPOINT
The previous shot was made from a standing position. The composition and the feeling of height are improved by a lower camera position.

at its largest aperture setting, or a combination of these.

Sports photography also frequently calls for the use of a telephoto lens. The professional needs a *fast* telephoto—one that gives him a close-up view of distant action, and at the same time enables him to use a fast shutter speed. A 300mm *f*-2.8 lens typically meets these requirements.

WHEN TO SHOOT

Let's get back to our hurdler. The first important step is to determine the best moment for the exposure. It's generally when the leading foot is at its highest point. This happens as the hurdle is being cleared. As indicated earlier, this enables you to pre-

focus on the hurdle, aim your camera and simply wait for the action.

When you press the shutter button of an SLR, the mirror must swing out of the way before the film can be exposed. This means the picture is actually made a fraction of a second after you *intend* it to be made. You must attempt to compensate for this by pressing the shutter button a brief moment *before* the desired peak action occurs.

PANNING

When the hurdler is going past you, rather than toward you, you can use panning effectively. Panning simply means that you follow the moving subject with your camera, keeping the

subject centered in the frame as you expose the film. If you pan at a shutter speed of 1/500 second, you can record the hurdler sharply against a blurred background. In the picture, this gives the impression of movement.

If you pan at a relatively slow shutter speed, such as 1/60 second, you can get some blur in the subject, as well as considerably more blur in the background. This can effectively give the impression of a subject that is not only moving rapidly across the image plane, but is at the same time performing several complex actions. Legs and arms will appear to be moving.

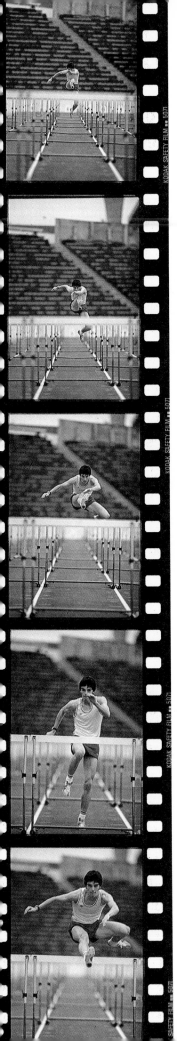

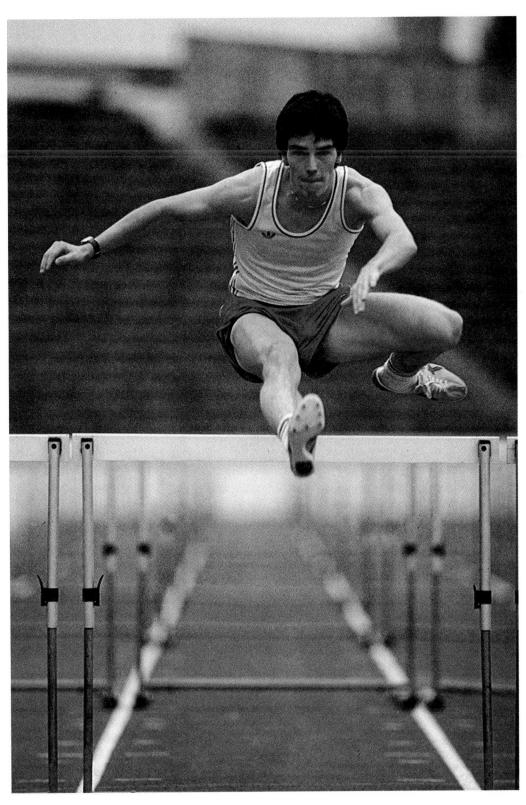

SHOOTING A SEQUENCE

To get a bigger image, the 135mm lens was changed for a 300mm f-2.8 lens. For the sequence on the left, a motor drive was used to advance the film and cock the shutter automatically between exposures. Without the motor drive, it would be impossible to shoot fast enough to capture all the action. The best shot of the sequence is enlarged, above. Focusing can be difficult when the subject is coming toward you at great speed. The solution was to pre-focus on the hurdle where the picture was to be taken.

Action Indoors

This section also deals with sports. As before, we're after peak action and the impression of movement in the image. However, there are some important differences. The hurdler was outdoors and was photographed by daylight, whereas we're now indoors. The gymnast is not going to move from one place to another. Unlike the hurdler, she is going to perform her activity more or less in one location. So the technique of panning is out.

What we're after here is depicting the grace of motion. It was decided to shoot a routine on the horizontal beam. First, the gymnast was asked to go through several exercises, so the photographer could choose a suitable one. When he had chosen the best routine, the gymnast was asked to go through it a couple of times, so the most interesting moments could be determined. This enabled the photographer to select the best camera position.

The ultimate aim was to show the entire routine in one photograph by using a long exposure time and appropriate subject blur.

1) THE FIRST TRY
A standard 50mm lens was used, so most of the balance beam was within the picture area. Beam exercises are best photographed from the side because the more interesting movements can be recorded from this viewpoint. On his first try, the photographer chose the wrong moment to make the exposure. Instead of catching the gymnast at the peak of a movement, he caught her between movements—a dull and unflattering moment. A meter reading from the gymnast's skin indicated an exposure of 1/30 second at *f*-1.8. This was too slow to freeze even this relatively slow movement.

2) THE RIGHT MOMENT
Here the gymnast was caught at the peak of a *backward walkover*. The picture has grace and interest and suggests action. The gymnast was asked to hold this peak position for a second or two, while the photographer recorded the scene with the slow shutter speed of 1/30 second. At that speed, the subject would have been blurred if she had been in motion. Film, lens and camera position were the same as above. Exposure was 1/2 *f*-stop less than in the above picture.

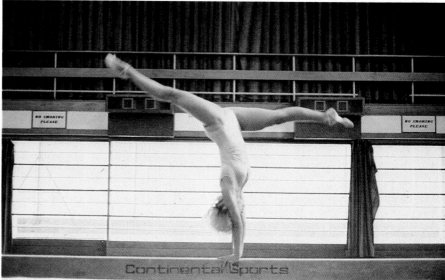

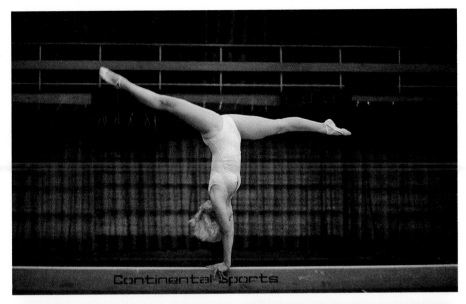

3) GETTING THE BACKGROUND RIGHT

The background is untidy and distracts from the subject. It must be changed so it's uniformly dark. Artificial illumination was called for. So the photographer could control the lighting, he closed all the drapes in the gym. Two 2000-watt photolamps were directed toward the balance beam and the area immediately above it. Bright background areas that caused unwanted reflections were covered with black paper. The exposure for this shot was 1/30 second at *f*-1.8.

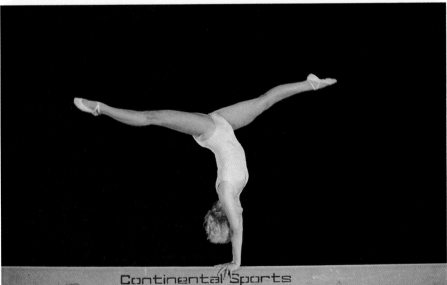

4) PLACING THE LIGHTS

The two 2000-watt lamps lighting the side of the gymnast facing the camera were carefully placed to avoid lighting the background. Two additional 1000-watt lamps were placed slightly behind the subject to create a rim light. This gives the subject the appearance of depth.

A meter reading off the gymnast indicated an exposure of 1/125 second at *f*-2.8 on ISO 200/24° film. A separate reading from the background indicated that it was 4 exposure steps darker than the subject, ensuring that it would reproduce virtually black in the photograph. The faster shutter speed has frozen the action—compare the rear foot in this and the above photo.

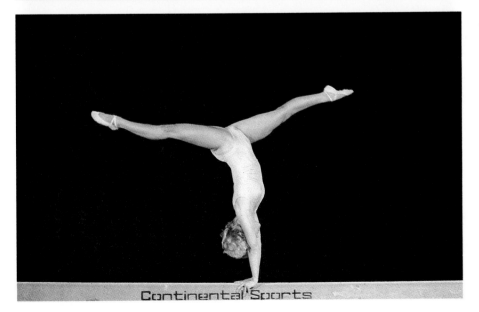

5) TUNGSTEN-BALANCED FILM

The previous photograph has a strong yellow cast because daylight-balanced film was used under tungsten illumination. Tungsten light contains relatively more red and yellow than does average daylight. Our eyes compensate easily for such color differences, so that we are not aware of them. Color film, however, records exactly what it "sees." Hence the need for color films that are specially balanced for specific types of illumination.

To get true color rendition, tungsten illumination calls for tungsten-balanced color-slide film, or for daylight film with appropriate color-conversion filters. Kodak Ektachrome 160 tungsten film was used here. This is only 1/3 *f*-stop slower than the Ektachrome 200 film used above, so the exposure was kept the same.

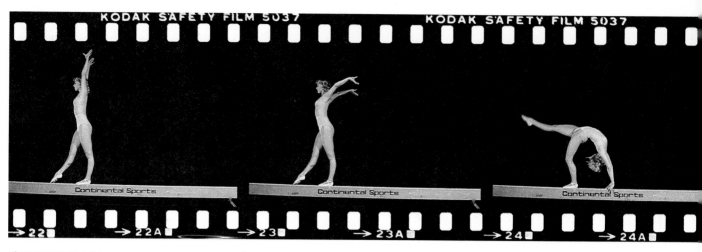

6) SHOOTING A SEQUENCE
The next step was to shoot several frames per second as the gymnast went through her routine. To do this, a motor drive was attached to the camera. The sequence is shown above. The gymnast's movement was in a backward direction.

7) USING A LONG EXPOSURE TIME
Now the photographer wanted to capture the entire routine on just one frame. This meant exposing for about 3 seconds—the duration of the routine. At the smallest lens aperture, the meter indicated an exposure of 1/2 second. The lamps were moved back to reduce subject brightness, so that a longer exposure time of 3 seconds could be given. The result is shown below.

8) ADDING FLASH
To get the combined blurred and still effects shown on the opposite page, the photographer added electronic flash. The flash was fired at the end of the long exposure. The long exposure provided the blurred image; the short duration of the flash gave the frozen, sharp image. The different color characteristics of the blurred and static images separate the two even more effectively. Daylight-balanced film was used. The sharply defined flash part of the image is correctly balanced; the blurred part has a distinct yellow color cast.

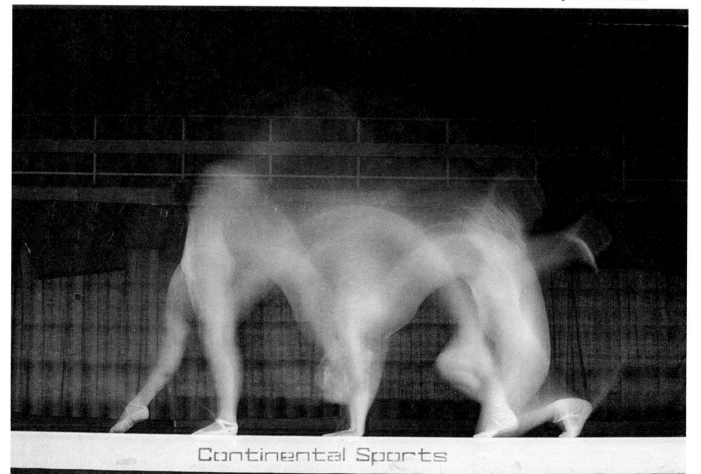

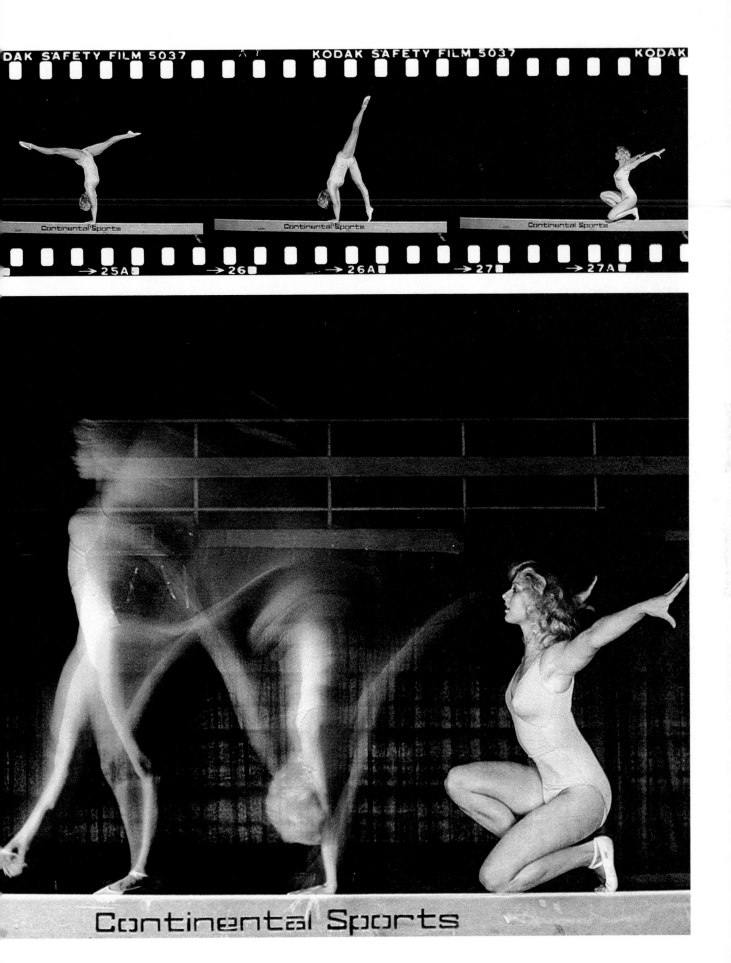

Panoramic Landscapes

A wide-angle lens can give you an impressive scenic view in a photograph. To get a truly sensational photographic rendition of an expansive scene, however, nothing can beat the *panorama*. It consists of a series of photos of a scene, each overlapping the next. The total panoramic view can be as wide as 130°, 240° or a full 360° circle. There's no limit. When enlargements have been made, they are carefully pieced together.

SETTING UP YOUR CAMERA

Find a location that gives you a clear overview of the entire scene you want to record. Then place your camera on a sturdy tripod that has a panorama head. It enables you to rotate the camera smoothly and evenly in a horizontal plane. A spirit level is a useful aid for keeping the camera viewpoint truly horizontal at all times.

If you shoot with the camera aimed for a vertical format, you'll get maximum height to the scene. The width is governed, of course, by the number of overlapping exposures you choose to make. If the scene doesn't have much height, you can operate the camera in a horizontal position. This reduces the number of shots you need to make to cover the view.

KEEP THE CAMERA LEVEL

Generally, the film plane in the camera should always remain vertical. If it doesn't, the perspective will change from shot to shot, making the joining-up of separate pictures difficult and obvious to the viewer.

Landscapes that have few straight lines and a horizon that is not always truly horizontal may allow you a little downward or upward tilt—but it would be wise to keep it to an absolute minimum. This will ensure that trees all grow straight upward, the way they are supposed to!

WATCH THE LIGHTING AND CLOUDS

Two enemies of the panoramic photographer are low sunlight and fast-moving clouds. The low sun causes image contrast to change drastically as you aim the camera in different directions. In the extreme case, you'll be shooting with the sun directly behind you and directly in front of you, all in the same panorama.

Fast-moving clouds are a problem, because you'll find it impossible to match them when you join up the separate pictures. The clouds will have moved between exposures.

Ideal lighting conditions occur with even overcast or summer midday sunlight, when the sun is high in the sky.

You don't normally need a fast shutter speed for panoramic views, but you do need extensive depth of field, especially if you are going to include some foreground interest. The exposure for the strip on this page—shown in final montage form on pages 44 and 45—was 1/30 second at *f*-11 on Kodak Plus-X film.

A 35mm lens was used here. Don't be tempted to use an ultra-wide-angle lens. Distortion at the edges would make accurate joins difficult or impossible.

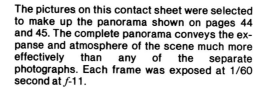

The pictures on this contact sheet were selected to make up the panorama shown on pages 44 and 45. The complete panorama conveys the expanse and atmosphere of the scene much more effectively than any of the separate photographs. Each frame was exposed at 1/60 second at *f*-11.

WHAT DIFFERENT CAMERAS WILL DO

▶ This wide view was taken with a Widelux panoramic camera (1), shown below. The camera takes 35mm film and gives a horizontal angle of view of 160° on a 24x59mm format. The panoramic camera makes wide views possible without the image distortion often associated with wide-angle lenses. A spirit level on the top of the camera ensures that the camera is absolutely level when in use.

▼ A medium-format 6x6 cm camera, such as the Hasselblad model (2), has a considerably larger image format than a 35mm camera. The larger format generally leads to better image quality. The square format lends itself well to some subjects, such as the scene below. You can also crop the image to get a vertical or horizontal composition. The film frame, below, is about as wide as that of the panoramic view, above. However, the angle of view possible with this camera is not as wide as with the panoramic camera.

▲ The most versatile and portable camera is the 35mm SLR (3). To use this camera for making panoramic views, follow the directions on the next two pages.

TO ENABLE YOU TO COMPARE FORMAT SIZES, THE THREE LANDSCAPES SHOWN ON THIS PAGE HAVE BEEN ENLARGED IN THE SAME PROPORTION.

1) LEVEL THE TRIPOD
Set up your tripod, adjusting its legs so the platform appears to be horizontal. To get the platform perfectly horizontal, place a small spirit level on it. Then make any necessary fine adjustments. Some tripods have a spirit level built in. Rotate the platform to a variety of positions, and make sure it remains horizontal. If it doesn't, adjust the tripod legs, as necessary. A perfectly horizontal camera pan is essential if the horizon is to remain horizontal on film, and your separate pictures are to join easily and properly.

2) PLAN THE SEQUENCE
Decide whether you want to mount the camera horizontally or vertically. The vertical format allows you to include more foreground; with the horizontal format you need fewer shots to complete the panorama. Decide where the panorama is to begin and end. Looking through the viewfinder, practice slowly panning through the entire view. While doing so, mark the tripod head, or note the position of the degree scale on the tripod, to indicate each position for an exposure. Remember to allow for adequate overlap between frames. Try to keep important image features in the center of a frame, so you don't have to cut and piece them together.

3) TAKE THE PICTURES
Focus the camera. Set the exposure. You are now ready to shoot. If you want to bracket exposures, don't change exposure from frame to frame. Shoot the entire sequence, then change exposure and shoot the entire sequence again. This enables you to get the entire panoramic sequence correctly exposed on one negative strip.

4) MAKE ENLARGEMENTS

First make a contact sheet from your processed film. Select the best-exposed sequence. Enlarge each frame of that sequence separately. Give each print exactly the same exposure and development. Adjust the enlarger lens aperture to give fairly long exposure times—at least 10 to 15 seconds—so that small variations in time will not be noticeable in the prints. When you join the prints together, even small density variations will show up very clearly, so take great care at this stage.

5) JOIN THE PRINTS

Start with the print at the far left of the panorama. Cut it somewhere within its right quarter, as shown. Sometimes you can make a clean vertical cut. Generally, it is best to follow natural boundaries such as the straight line of a tree trunk, or the side of a building, or the clear outline of a rock formation. Cut in a place where it is least likely to be visible. Lay the next print in the sequence under the first, and line the two up precisely. Without moving them, carefully cut the second print along the same lines as the first. Use a sloping cut, slicing away more of the paper base than the emulsion, to create an almost invisible join. Repeat the above procedure with all prints.

6) PASTE UP THE PANORAMA

Make the montage by mounting the component parts on a stiff card. Use an adhesive that dries slowly enough to give you time to move the parts into the exact correct position. Some cards and adhesives contain chemical substances that will damage the photographic image with time. Consult your photographic dealer for materials that are safe to use with photographs. To get a clean finish, trim the borders of the completed panorama. Where a join is clearly visible, you can practice your skills at photographic retouching. Warning: It's better to underdo than overdo retouching. You can always add more, when needed, but it's difficult to remove an excess.

Creative Landscapes

A photographer can interpret landscapes in many different ways. On the preceding pages you learned how to make a spectacular panoramic view. Most landscape photography by the relatively inexperienced amateur is done in a conventional way, frequently with the use of a standard 50mm camera lens.

WIDE-ANGLE OR TELEPHOTO?

You can begin to do some really creative landscape photography if you think in terms of lenses of different focal lengths. In this context, a landscape can be anything from an expansive distant view to a close-up detail in a gnarled tree trunk or a delicate wood carving in a church door.

In this section we'll explore some of the possibilities offered by lenses of extremely short and long focal lengths. We'll discuss the most effective techniques and some possible errors you may make.

THE WIDE VIEW

When you use a wide-angle lens, you must give special consideration to the foreground area of the scene. The image area is likely to include objects that are only a few feet away.

An empty foreground makes for a dull landscape. You can place people in the desired position in the foreground. Or, you can use another movable object, such as a car. When your foreground objects are fixed, such as a tree or a wall or a gate, you must change your viewpoint to get the composition you want. With a wide-angle lens, a small change of position can make a great difference in composition, so look at the viewfinder image carefully as you move about.

Be sure to use a lens aperture small enough to ensure sharp focus over the entire scene. Fortunately, depth of field with a wide-angle lens is usually adequate, even at a moderate lens aperture setting.

1) THE FIRST SHOT
This photo was taken with a 20mm lens from a standing position. The large expanse of uninteresting foreground makes the picture dull. Exposure was 1/60 second at f-11 on ISO 64/19° film.

4) THE FINAL RESULT
The lighting had improved and the sky looked more interesting. A graduated gray filter was used to darken the sky, without affecting the foreground. Exposure was 1/30 second at f-22.

2) ADDING FOREGROUND INTEREST
By moving only 10 feet to the right, the photographer was able to include the tree in the foreground. The picture already looks much more interesting.

3) LOWER VIEWPOINT
A lower camera viewpoint makes the tree project above the horizon. This gives it added prominence. For maximum depth of field, the exposure settings were changed to 1/15 second at *f*-22. A tripod was used.

50mm LENS FIELD OF VIEW
This is how the castle appeared to the standard camera lens. The small framed area is the center of interest, shown in the following pictures. Here, it is much too small and the composition is not interesting.

300mm LENS FIELD OF VIEW
The castle is now clearly featured in the picture. There's just enough foreground and background to set the scene and give the picture some depth.

THE LONG VIEW

With a telephoto lens, you'll want to photograph specific detail within a scene, often at a great distance. To ensure sharp images, a tripod is a must. Avoid taking telephoto pictures in hazy conditions, unless you're after a specific effect. Haze reduces image contrast and apparent sharpness over a long distance and may give a color photo a bluish cast.

On very hot days, watch out for the familiar shimmer of heat haze—it, too, drastically reduces image quality.

The photographs featured here were made with a 20mm lens and a 300mm lens. The magnification ratio from one to the other is 1:15. Imagine a photo made with the 20mm lens occupying this entire page. A photo made from the same viewpoint with the 300mm lens would give you a full-page picture of a section of the 20mm picture that was only about 3/4 inch high.

Of course, you needn't go to these extremes in your landscape photography. These examples are provided only to make some important points. You can use a wide selec-

tion of lenses, or you can even work with a variable-focal-length zoom lens.

THE FINAL RESULT
The viewpoint is the same as in the previous photo, and the same lens was used. The lighting has improved. Don't photograph distant scenes when there's a lot of haze—unless you're after a special effect. Exposure was 1/60 second at *f*-16 on ISO 64/19° film.

Photographing a Mother and Baby

Let's go into a professional photographer's studio and watch how he makes a portrait of a mother and her baby. The equipment used for these pictures was a 35mm SLR with a 70-210mm zoom lens. The lens was set to a 100mm focal length. Lighting was electronic flash. The brief flash duration ensured that there would be no subject movement during the exposure.

Kodak Ektachrome film, with a speed of ISO 64/19°, was used. The camera lens was set at f-11.

It's a good idea to let the mother know in advance that a rested baby will give the best cooperation. To get an attractive photograph, the baby should look alert and interested in what's going on.

FROM SNAPSHOT TO PORTRAIT

The first picture on these two pages is no more than a snapshot. The second is much closer to a professional portrait. The captions tell you how the improvement was made. On the next two pages are other attractive variations.

Portraits are usually made in the vertical format. However, when two heads are involved, the horizontal format often gives a satisfying composition.

Be sure to shoot enough film. You

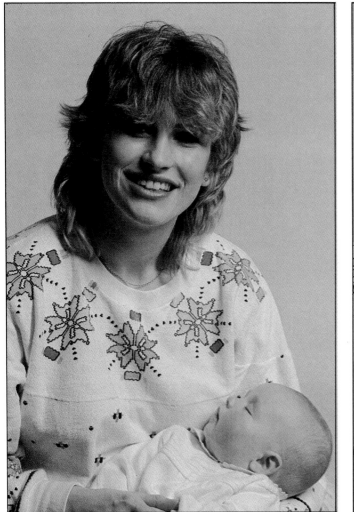

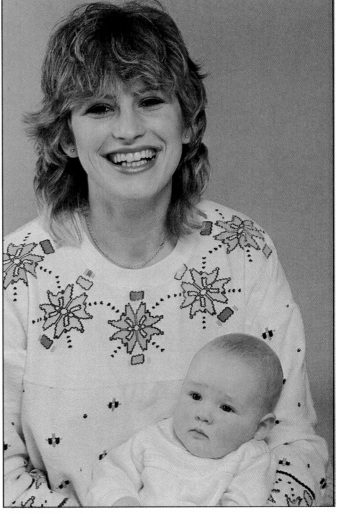

1) A SNAPSHOT
This a reasonably pleasant snapshot. However, it lacks the quality of a professional portrait in three important ways: Only one lamp was used, resulting in harsh shadows; the white background reproduced as a dull gray because the lamp was too far from it; the pose was poor, showing no relationship between mother and baby.

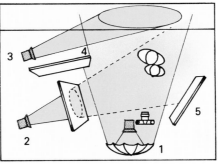

2) CONTROLLING THE LIGHT
The light is moved to provide more flattering modeling on the mother's face. A second lamp is added as a *fill light* to lighten harsh shadows.

THE STUDIO SETUP
1) Main light with reflector umbrella.
2) Fill light behind diffuser screen.
3) Background light.
4) Baffle board to prevent light spill toward camera.
5) Reflector card.

can't order a baby to adopt a certain attitude or smile at you. You have to be quick, and just snatch every good moment on film. Shoot until you're satisfied, or you run out of film, or the baby falls asleep.

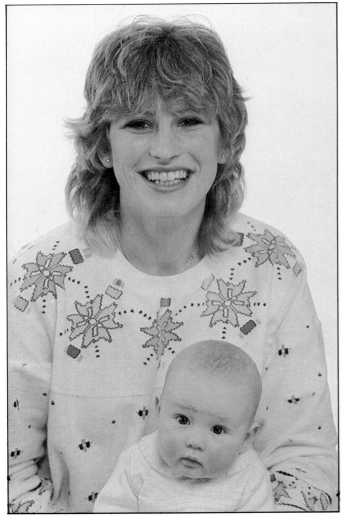

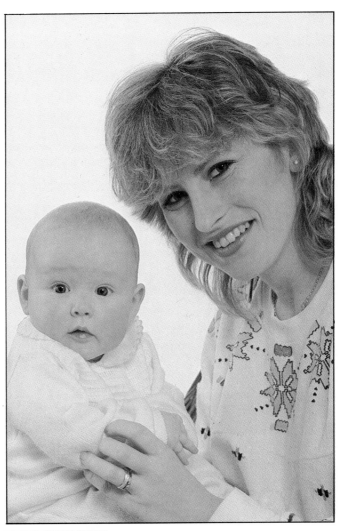

3) LIGHTING THE BACKGROUND
A separate flash head is placed close to the background, to illuminate it and make it appear nearly white. To prevent light spillage from this lamp toward the camera lens, a baffle board was introduced—see the studio setup sketch at left.

4) IMPROVING THE POSE
Until now, the baby had been sitting on the mother's lap. The two heads were at different ends of the picture, with little apparent communication between the two. The faces were brought closer together by placing the baby on the arm of the mother's chair—see the sketch at left. This tighter composition also enabled the photographer to zoom in closer for a larger image.

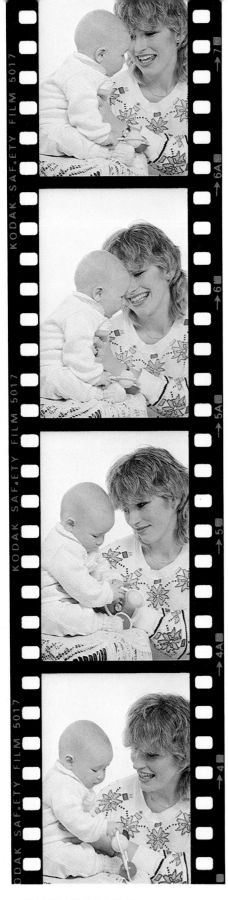

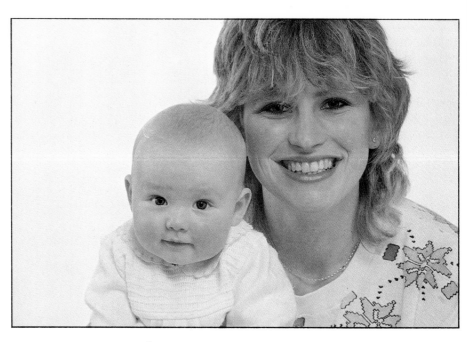

▲ USING THE HORIZONTAL FORMAT
Most portraits are taken in the vertical format. Up to this point, the pictures in this section had been, too. The photographer now tried the horizontal format. It lends itself well to portraits including two heads side by side. For this appealing study, the photographer asked the mother to look toward the camera. He then attracted the attention of the baby.

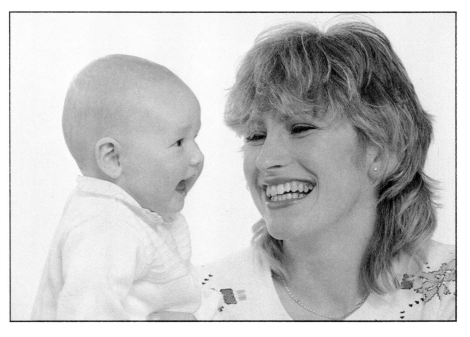

▲ SHOOT LOTS OF FILM
Candid photography of babies is unpredictable. To be sure of getting some good photos, don't spare the film.

▲ ANOTHER CANDID SHOT
The mother was asked to look toward the baby, and to try and get the baby to look at her. It wasn't easy to get the baby's cooperation. An assistant, standing to the right of the picture area, attracted the baby's attention with a doll.

▶ THE BEST PICTURE
This was the photograph the photographer considered the best of the session. Not surprisingly, the mother couldn't hold this pose for very long, so only a couple of exposures were made. But the photographer made sure one of them was a winner.

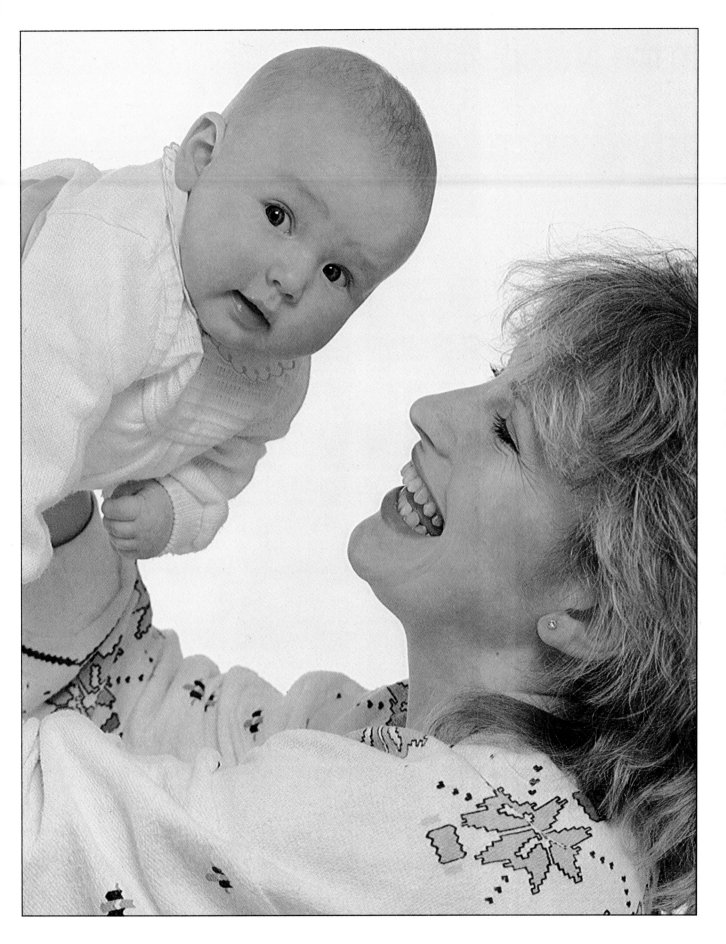

Children
in the Studio

1) A SIMPLE SNAPSHOT
This is a long way from being a formal portrait. The girl is wearing the clothes in which she arrived at the studio. They may be comfortable, but there's nothing very festive about them. The background is a dull brown door that does nothing to add sparkle and life to the picture. The pose and expression are stiff and unrelaxed.

The framed portrait above is associated with professional studio photography. Most amateurs take it for granted that they can't take pictures like that. Yet, with a little bit of know-how and the right tools, it's a very rewarding form of photography well within the reach of the capable amateur. In this section, you can follow the step-by-step methods that make a good studio portrait of a child.

BE PREPARED AND WORK FAST

For the photographer who wants to shoot formal studio portraits of children successfully, there are two rules worth remembering. First, take as much time as you need to get ready for the session. Before you start shooting, be sure all lights, backgrounds, props, camera and accessories are in the right place and ready for use. Second, take as little time as possible shooting the pictures. Children get tired and bored very quickly. Once a child loses interest, you're not likely to get an appealing portrait.

CLOTHING AND HAIR SHOULD BE NEAT

Advance preparation isn't limited only to the studio and your equipment. The child generally needs some preparation, too. Clothing should be neat and appropriate. Some parents like to see their children in nice suits or dresses, such as are associated with classic portraiture. Others—and certainly the children themselves—prefer jeans or other casual clothing. It doesn't matter *what* the child wears, as long as it looks attractive and appropriate.

Basically, the same applies to hair. A girl can have short hair, or a boy long hair. And each can look attractive. The important thing is for the hair to be well groomed.

The sequence of photos on these pages progresses from a background of an ordinary brown door to a carefully lit portrait in front of an attractive and separately lit blue background.

2) A CHANGE OF CLOTHING

Street clothes were changed for an attractive pink-and-white dress. Adults who bring children for studio portraiture should be advised by the photographer well before the shooting session what clothing is most suitable. Here, the hair was tidied up somewhat, too. And there's the beginning of a smile.

3) A CHANGE OF BACKGROUND

A roll of bright-blue studio background paper was hung up behind the girl. Special background paper comes in large rolls and is available from photographic dealers. If you rarely need a background, you may not want to buy one of these. Any brightly colored paper or fabric will do the same job, as long as it is free from creases and seams. Be sure to select a color that will not clash with the colors of the subject's clothing.

EXPRESSION IS CRITICAL

Expression is of ultimate importance in a child portrait. Always be ready to capture that special smile or appealing look. If the expression isn't right, nothing else can save the picture.

Be sure to shoot the child from various angles. Shoot full length, three-quarter length, and head-and-shoulder studies. Shoot smiling, serious and mischievous expressions.

The pictures here were all taken on Ektachrome 64 film in a 35mm SLR camera fitted with a 70-210mm zoom lens. The lens aperture for each exposure was about f-11.

4) LIGHTING THE BACKGROUND
In the opening snapshot on page 54, only one lamp was used to light the subject and the background. Here the background was brightened with a separate light. The background light was fired by a *slave unit,* triggered by the light coming from the main flash. No connecting wires are needed. Many modern flash units—even some designed for the amateur—have built-in slaves.

5) LIGHT ON THE HAIR
To put some sparkle in the hair and bring out its color, a small light was directed from behind the girl toward the right side of her head. This flash was fired by a cable from the camera. To shield the camera lens from unwanted flare from this lamp, the photographer used a baffle board, as shown in the diagram below. Also note the reflector board to the right of the camera. Its purpose was to throw more light toward the left side of the girl's face.

6) A RELAXED EXPRESSION
Now that he had the lighting and background the way he wanted them, the photographer could concentrate on the girl's expression. She was sitting on a stool, her hands clasped in front of her. To keep her relaxed and interested, the photographer asked her questions about school and friends.

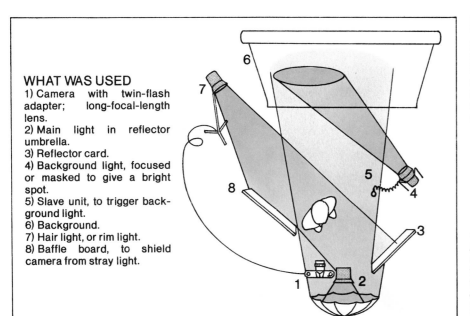

WHAT WAS USED
1) Camera with twin-flash adapter; long-focal-length lens.
2) Main light in reflector umbrella.
3) Reflector card.
4) Background light, focused or masked to give a bright spot.
5) Slave unit, to trigger background light.
6) Background.
7) Hair light, or rim light.
8) Baffle board, to shield camera from stray light.

▶ THE FINAL PORTRAIT
The girl was asked to place her feet on a box about 6 inches high. This enabled her to put her elbows on her knees and place her hands in the position shown. She was asked to turn her head a little away from the camera while still looking toward the camera. This was a more attractive pose and showed more of her shining hair.

◀ THE SETUP
Although these portraits were taken in a studio, they could just as easily have been taken in your home. The setup includes three flash units—two fired by cable and one by slave unit. The main light is mounted in a reflector umbrella. A reflector card, a baffle board and a suitable background complete the required equipment.

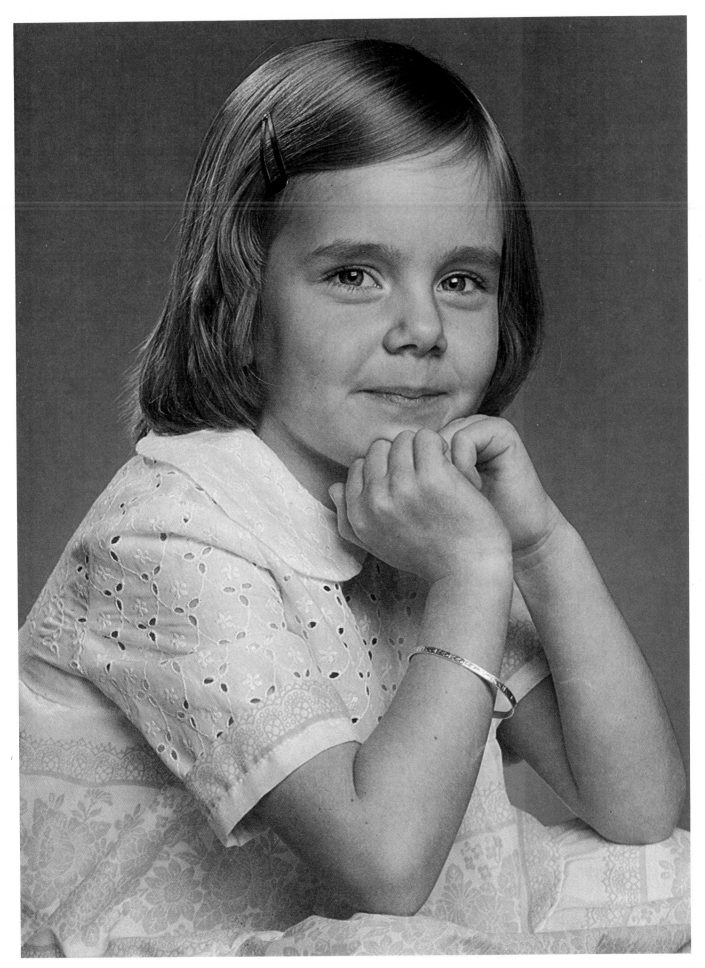

Children Outdoors

Many portrait photographers prefer to photograph people at home, or in their normal work or play environment, rather than in the formal atmosphere of the studio. Children, in particular, tend to look more appropriate and feel happier in their accustomed surroundings. The subject for this photo session was a 3-year-old boy named Ben.

LONG LENS AND LOW VIEWPOINT

To get the best pictures of small children, it isn't necessarily wise to do things in the *normal* way. Normally, you might use a standard-focal-length lens on the camera and shoot from a standing position. A typical result is shown in the picture at left. The child is dwarfed, and is looking up in an awkward way, because the camera viewpoint was much too high. Also, the angle of view is much too wide—the child occupies too little space and most of the image area is empty.

The space problem could be solved by simply coming closer to the subject, to fill the frame. But at a shooting distance of no more than about 3 feet, you'd pay a price —distortion. Also, when you're that close the child is not going to be comfortable and won't act in a natural, spontaneous way. A long-focal-length lens, such as the 105mm telephoto used for the picture on the opposite page, is essential.

Get down to the child's level, or raise him up to yours. All parents know that looking down at children doesn't produce the happiest expression in them!

OCCUPY THE CHILD

To get a child to look natural, he must be interested in something or occupied in some way. At first, Ben just kept looking at the camera in a questioning and self-conscious way. His attention had to be diverted.

A nearby farmyard did the trick. It was not difficult getting the farmer's cooperation. In a short time Ben, photographer and mother were at the entrance to the barn.

Ben was placed on top of a straw bale. This was a useful location for several reasons. First, it raised Ben up by a couple of feet, making it easier for the photographer to shoot him at his own level. Second, it kept Ben

◄ NOT THIS WAY!
The lens on the camera was a standard 50mm; the shooting distance was no more than about 5 feet; the photographer shot from a standing position. The frame is not filled, giving a poor composition. The child looks dwarfed, and is looking upward in a very awkward manner.

► THIS WAY!
Ben was lifted onto some straw bales and photographed at his own level with a 105mm lens. This lens enabled the photographer to fill the frame without coming uncomfortably close to the boy. The child is happily occupied and not conscious of the camera's presence.

1) GETTING CLOSER
Here, instead of using a longer lens, the photographer used the standard lens and moved closer than he was for the shot on page 58, to get a larger image. The image is bigger, but the viewpoint is now even higher.

2) CHANGING LENSES
A better way to get a larger image is to use a longer-focal-length lens. The increased distance between photographer and child automatically gives the impression of a lower viewpoint. Exposure with the 105mm lens was 1/125 second at ƒ-2.8. The fast shutter speed helped the photographer avoid camera shake with the longer lens.

3) THE RIGHT LOCATION
Ben had been restless on the lawn, so he was taken to a nearby farmyard. He was placed on some bales of straw, within view of some cows. His interest is reflected by his expression. The camera viewpoint was now at the right height.

securely in one spot—it was not easy for him to jump off and run around. Third, he was looking straight at the cattle, and this kept him interested and amused long enough to produce several interesting photographs.

WATCH THE BACKGROUND
Although it's important for the child to be looking at something that holds his interest, it is equally important for the photographer to see something interesting behind the child—the background. It should be appropriate, neat and form a pleasant composition. Always keep a critical eye on the background.

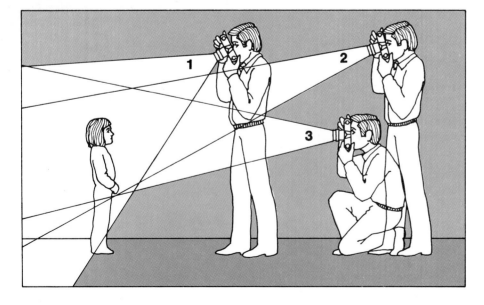

◄ Inexperienced photographers tend to take most of their pictures from a standing position. When photographing children, this is not the best approach. 1) With a standard lens you have to come very close. This causes a standing adult to tower over the child. 2) If you use a longer lens and move farther from the child, the angle of view is more in the horizontal direction, and the child is not dwarfed as much. 3) The best solution is to use a longer lens *and* a lower viewpoint. Or, you can raise the child up, so you can shoot eye-to-eye.

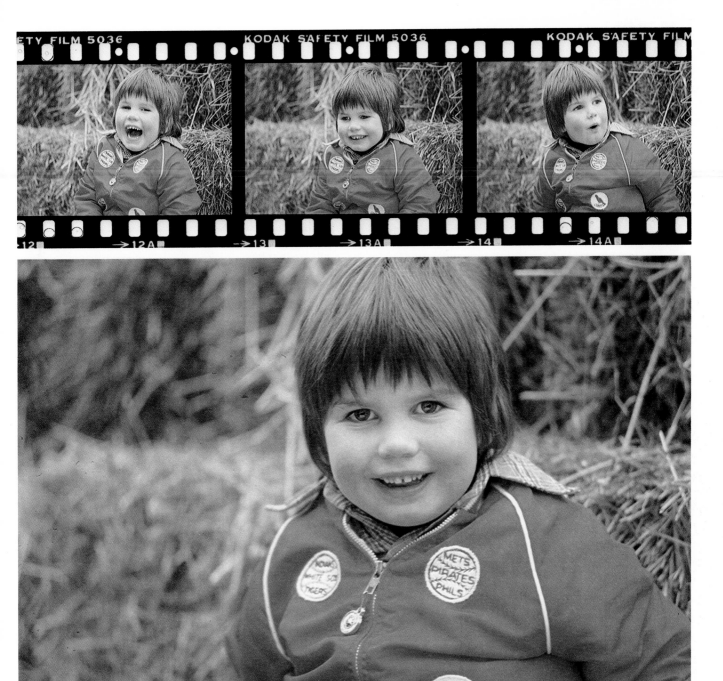

Ben was placed on the bales of straw, facing the cows. The horizontal format was used in case he excitedly waved his arms around. This could lead to an interesting and appealing picture. While Ben was occupied with the cattle, a whole roll of film was exposed. Here are some of the best results. All photos are on Ektachrome 200 film. Exposure was 1/125 second at *f*-2.8.

People at Work

The most successful portraits of people are often those showing them doing the things they do best. When you depict a person at his work or hobby, you not only place him in an appropriate environment, but also tend to capture an expression of pride in achievement. This makes for a really effective character study.

We accompanied a photographer to a blacksmith's shop and observed him photographing the blacksmith at work. It was a picturesque place, so it wasn't difficult for a skillful photographer to produce some appealing photographs of the scene.

But people can be photographed effectively at any occupation. The main ingredients for success are an appropriate, well-composed and lit background, and some convincing action on the part of the subject for the portrait.

When you're working in a confined space, a wide-angle lens is often called for. With the blacksmith, a low camera angle was adopted to convey the feeling of physical power associated with this kind of work.

The activity must look authentic. There must be no indication that the subject is aware of the camera. If it's necessary to ask the subject to pose and stay still for a second or two because of lighting limitations, be sure that the pose is believable.

Appropriate lighting is important, not just for the subject, but also for the surrounding space and background. Try to use the natural light of the scene as much as possible. If necessary, use artificial light, but aim it from the direction where natural light might reasonably be expected to come from. Avoid on-camera flash.

THE FIRST SHOT—OUTSIDE THE WORKSHOP
This is a simple snapshot of Jim, the village blacksmith. It was taken ouside his workshop. The photo tells you little about the blacksmith and nothing about his work.

THE LAST SHOT—THE BLACKSMITH AT WORK
Here, Jim is busy making a horseshoe. We know right away what kind of work he does. But the picture tells us more. It tells us that the blacksmith's shop is hot and dimly lit, and that the work is physically hard. A 24mm wide-angle lens and available light were used. The low camera angle emphasizes the power of the hammer blows on the horseshoe. The exposure on Ektachrome 64 film was 1/8 second at f-4.

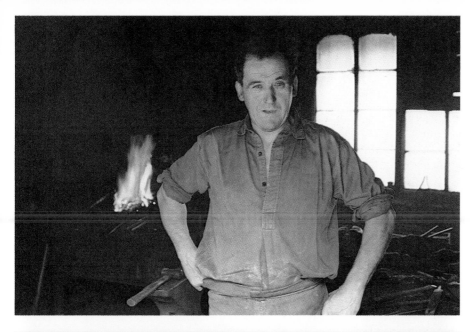

1) MOVE INSIDE

Once you get inside the shop, you get hints of the kind of work involved. Jim is standing in the doorway—but he isn't doing anything yet that tells us that he is a blacksmith. A horizontal format was used to get in as much as possible of the workshop, but the 50mm lens still didn't give an adequate angle of view. This portrait was shot by daylight only. A meter reading from Jim's face indicated an exposure of 1/15 second at *f*-4.

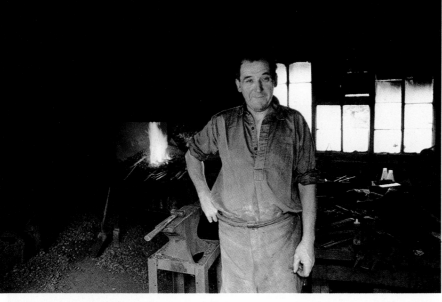

2) CHANGE TO WIDE-ANGLE LENS

The 24mm wide-angle lens takes in almost twice as wide a view. It's now easy to see that we are in a blacksmith's shop. The flame in the background is now recognizable as a forge. The anvil and the table covered with tools are clearly visible. The background is now sharper because the wide-angle lens gives greater depth of field at the same lens aperture. The camera position and exposure were the same as for the top picture.

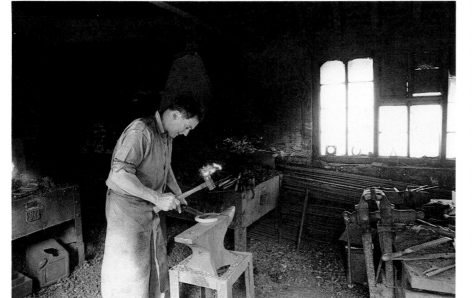

3) GETTING TO WORK

Up to now, Jim has been standing in his shop, looking at the camera. It's time to get to work. As Jim worked normally, it became evident to the photographer that the hammering movement was too fast to stop on film at the shutter speed he'd been using. So Jim was asked to pose in the hammering position without moving. He was told not to stand stiffly, but to adopt the stance he would have when actually doing the work. Now we have a picture of a blacksmith at work, rather than just a picture of someone standing in the shop. The exposure was increased to 1/8 second at *f*-4, because Jim had moved farther into the shop, away from the light coming through the open door. This is a satisfactory study of the blacksmith at work. But it can be improved by the addition of a little motion—see the next picture.

4) ADD A LITTLE BLUR

To add a little blur to the hammering action, Jim was asked to stand as still as possible, while slowly moving the hammer up and down. The blurred hammer and arm suggest action. The exposure time for this shot was 1/4 second. An amber 81B light-balancing filter was put over the camera lens to warm skin tones a little. This gives the impression that Jim was actually lit by the reddish glow of the fire instead of daylight coming through the open door. To crop the image tighter, the photographer moved the camera closer to Jim.

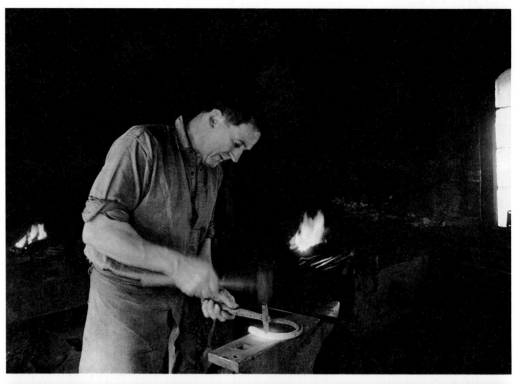

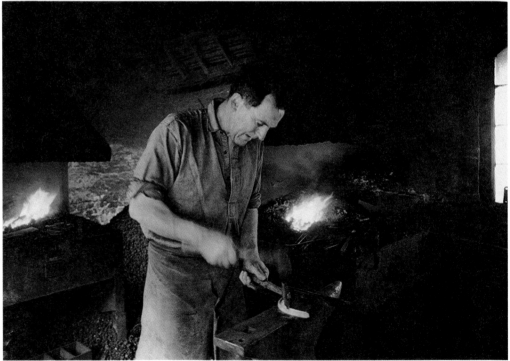

5) LIGHT THE BACKGROUND

In the above picture, only the blacksmith is lit. Apart from the glow of the horseshoe on the anvil and the two flames in the background, everything is in darkness. To add a little detail and dimension to the scene, a small tungsten lamp was placed in a concealed position near the left edge of the scene. To avoid a reddish color cast from the tungsten light on the daylight-balanced color film, a large blue gelatin filter was placed in front of the lamp. Be careful not to use too strong a light in such a situation, because this could easily destroy the prevailing atmosphere of the scene.

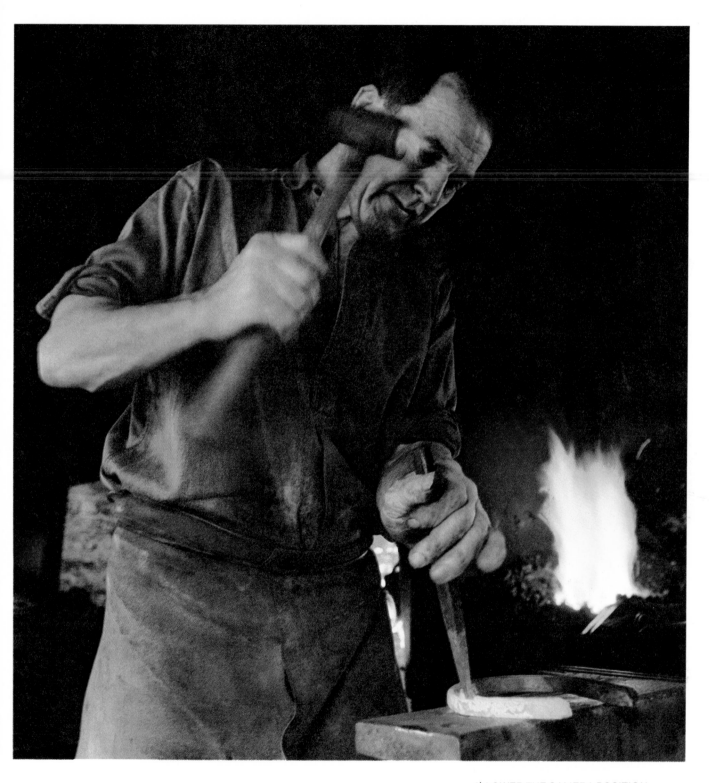

6) LOWER THE CAMERA POSITION
For this shot, the photographer came closer to the blacksmith and shot from a lower position. The low angle makes the subject appear to have power and strength—an appropriate impression for a blacksmith. In this instance, it also helps the composition, bringing the face closer to the action. Exposure was 1/8 second at f-4.

A Nude in Black-and-White

Most amateur photographers don't hire professional models for their first attempts at nude photography. They photograph their wives or girlfriends. That's probably the most sensible way. It enables them to work with someone they already know well and with whom they feel comfortable. It also allows them to work in a leisurely manner, because they are not paying a large fee for every hour that passes.

KEEP IT NATURAL

Start at the beginning. If you have never done nude photography before, and if your model has never posed for such photographs, you shouldn't be tempted to try and produce a slick glamour photo right away. The result could be disastrous.

Start with normal and believable situations. For example, you could ask your model to comb her hair, to sit and read a book, or simply to look out the window. Concentrate on a natural pose and expression—one she and you feel comfortable with—rather than on glamour.

Give your model a chance to take an active part in the session. Have her suggest poses and props. She knows best how she feels comfortable and natural. You can learn from this and, if you want to, make your own modifications and changes.

FAST FILM AND AVAILABLE LIGHT

The session illustrated here was shot with Ilford HP5 film, having a speed of ISO 400/27°. The fast speed was necessary so the photographer could shoot indoors by available light only, and use a sufficiently fast shutter speed to avoid camera shake.

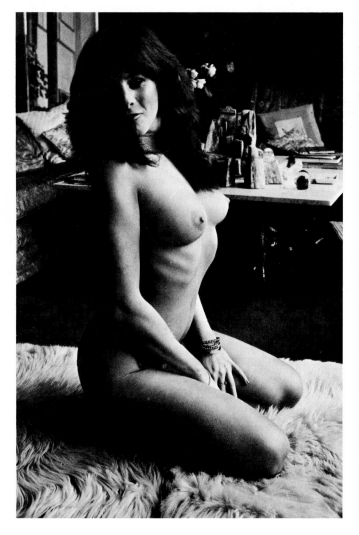

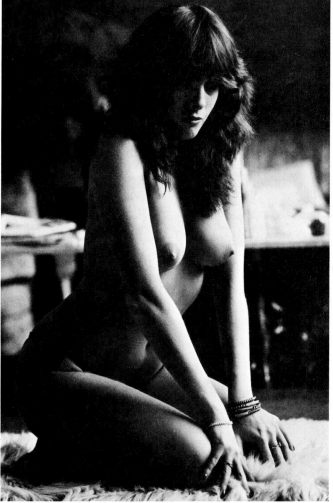

1) THE FIRST TRY
This opening shot was taken with a 35mm wide-angle lens. The camera-to-model distance was about 5 feet. The photo has several unattractive features: The lighting is too contrasty—half of the face is lost in deep shadow; the extremely close viewpoint has caused some figure distortion; the background is messy and obtrusive.

2) CHANGE LENS AND CAMERA DISTANCE
Here, an 85mm lens was used and the distance from the camera to the model was extended to about 12 feet. The perspective of the body is greatly improved. The longer lens reduces depth of field, putting the background out of focus. However, it still looks messy and distracts from the theme of the picture. Although the head is pointing more toward the window and there is now some detail in the shaded side of the face, contrast is still too high.

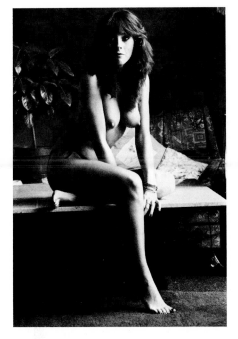

3) A MOVE TO THE TABLE
This is an attractive variation of the previous pose. The model is now sitting on the coffee table, one leg extended to the floor. The background looks better. An unsightly support below the table has been covered with a piece of black velvet.

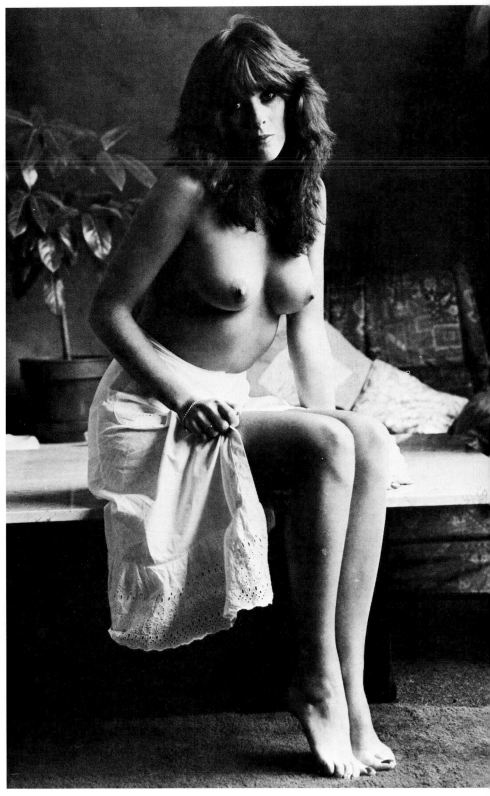

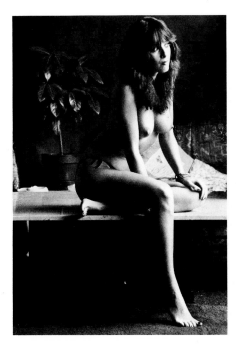

4) ANOTHER VARIATION
The model was asked to look toward the window. This lit her face more uniformly. The model suggested moving her hand from the table edge to her left knee. She looks comfortable and natural.

5) ADDITION OF A SLIP
The bikini bottom looked unnatural in the domestic setting, so the model put on a white slip. The pose is slightly different—she now has both feet on the floor. She has also arched her feet and raised her heels. This improves the shape of her legs. All three photos on this page were made with the 85mm lens. Exposure in each case was 1/125 second at f-2.8.

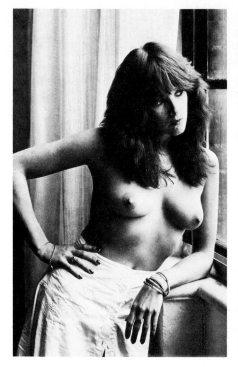 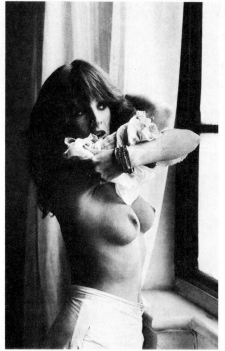 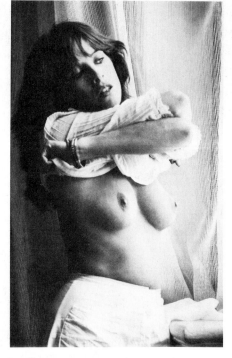

6) OVER TO THE WINDOW
The available light level in the center of the room may at times be too dim for photography. By a window, with fast film, there's usually enough light. For soft illumination, avoid direct sunlight. You can also cover the window panes with translucent tracing paper, as was done for this picture.

7) SOME ACTION
If a model feels unnatural or self-conscious in a pose, giving her something to do often helps. In this photo, the model is taking off her blouse. In doing so, she not only looks natural, but she has adopted a better pose.

8) A SOFTER IMAGE
By using a soft-focus lens attachment over the lens, the image has been noticeably softened. A further softening effect was achieved by covering the dark and hard outline of the window frame with a lace curtain.

Any room with a sufficiently large window is suitable for this kind of work. It reduces your basic equipment needs to camera and lenses.

When you plan a nude session, be sure the chosen room is warm enough. For the model to feel relaxed—and for your pictures to be free of goose bumps—the temperature should be several degrees higher than normal room temperature.

PREPARE THE MODEL
Plan ahead. Ask your model not to wear any tight clothing for several hours preceding the shooting session.

She should watch out for straps, elastic, belts and similar items that could leave marks on the skin. One well-known Hollywood photographer of the nude, who used to drive his models a hundred miles or more into the desert for a session, insisted that they wore nothing but a robe for the whole journey for that reason.

Finally, remember that nude photography does not demand that the model must be totally nude in every picture. Some of the most effective studies are made with the use of a bikini bottom, a blouse or even a towel.

9) THE DESIRED RESULT
This is one of the photographer's favorite pictures from the session. It incorporates features from several of the previous shots. The image is soft and the background is unobtrusive. The model is active, removing her blouse. The panties have replaced the slip, to eliminate the unflattering hard line around the waist. The pictures on these two pages were made with an 80-200mm zoom lens, set to about 180mm.

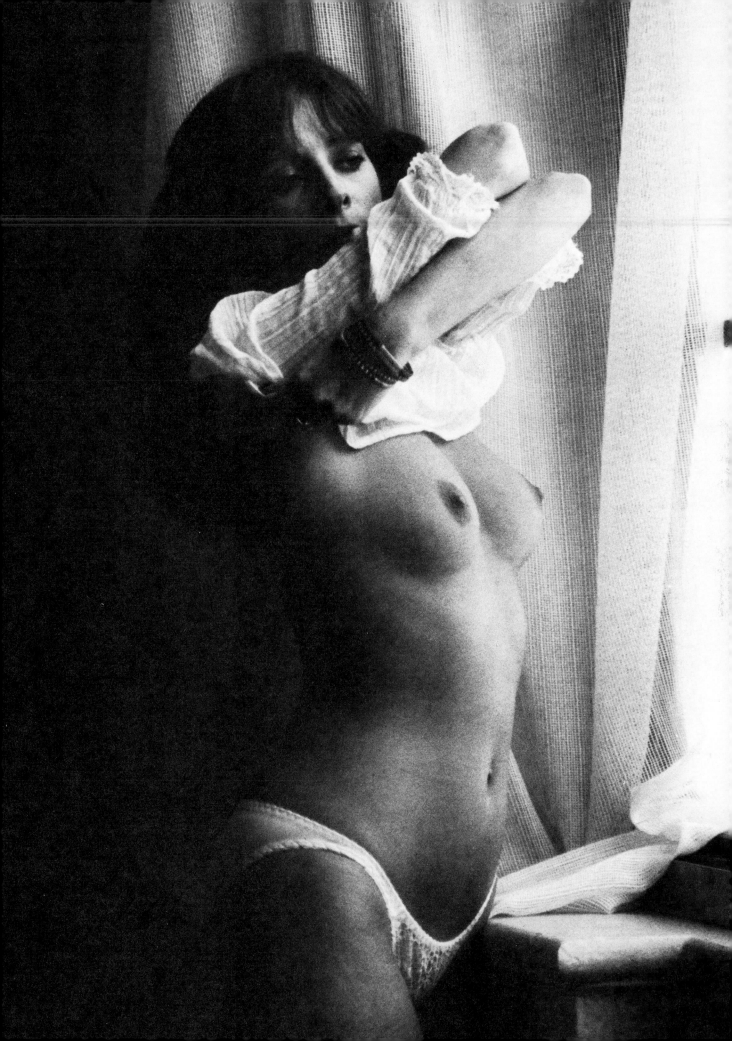

Still Life by Available Light

Still-life photography can be a real test of your photographic skills as well as your imagination. The basic requirements are not great. You need a camera, standard lens and tripod. If you don't have photographic lights, you can begin with daylight coming through a window.

TEST YOUR CREATIVITY

Test your creative ability by collecting a few everyday household items from around your home and putting them together into an attractive composition.

The photo below left shows some typical items, just as they were found in the photographer's home. Starting with these, he slowly improved the arrangement, setting and lighting, until he got the final still-life study shown below.

YOU NEED DEPTH OF FIELD

You're going to be close to the subject, so you'll need extensive depth of field to get the entire composition sharp. You needn't necessarily choose a fast film to enable you to stop the lens down. Because the objects won't move, it makes more sense to put your camera on a tripod and use a long exposure time.

The tripod has an additional advantage. It ensures that the camera is always in the same place relative to the objects. This makes control and changes in the composition much easier.

▼▶ FROM SNAPSHOT TO STILL LIFE
The photo below is a snapshot of the items, just as they were found. The illumination is also just the way it was found—daylight through the window.

The large photograph on the right represents a carefully arranged and lit still-life study. Here are some of the more obvious improvements:
● Composition: The items have been rearranged. Some have been removed and others added, until the composition looked well-balanced.
● Depth of field: In the snapshot below, the two nearest items are noticeably unsharp. For the large photo, a small lens aperture was used, and focus carefully controlled to ensure sharpness over the entire setup.
● Background: In the snapshot below, the background was shot exactly as it was found. For the still-life study, the photographer added a lace curtain to give a soft and uniform background and a plant to frame the composition. As a special touch, he used a graduated filter to warm the background part of the picture.

The photographs on these pages were made on Ektachrome 64 film. The gradual construction of an artistic still life from a simple snapshot of some objects is described with the series of pictures that follow on the next two pages.

MANY POSSIBILITIES

Your still-life studies don't have to consist of domestic items, such as shown in the example reproduced here. You can construct all kinds of realistic scenes with the use of dolls, toy soldiers, artificial landscapes, and so on. Clouds can be painted on a blue paper background. By cutting a circular hole in the "blue sky" and lighting the hole from behind, you can create sunshine. There's really no limit to what you can do.

FRAMING AND FOCUS

The tripod-mounted camera was carefully positioned to frame the composition in the desired manner. After carefully focusing on a point about one-third between the front and back of the composition, the photographer stopped the lens down to f-22. He then pressed the depth-of-field preview button and checked the scene through the viewfinder, to make sure everything was in sharp focus. If your camera doesn't have a preview button, stop the lens down as far as possible and check the lens depth-of-field scale. At f-22, a through-the-lens exposure reading indicated an exposure time of 1 second.

BACKGROUND

The vertical window frame spoils the composition. Also, the grass background is not appropriate. Because the light through the window was the main light source, any background over the window had to be light and translucent. A lace curtain was chosen and carefully draped behind the still life. The distance between the still life and the curtain was sufficient to throw the curtain slightly out of focus. If the pattern on the curtain were too sharp, it would distract your attention from the photo's theme. The addition of the curtain called for an exposure increase of about 1/2 exposure step.

COMPOSITION

Now the photographer's attention was directed to the composition. He thought it could be improved. The grapefruit was too dominant. It was replaced by a bunch of grapes. The small brass inkwell looked attractive, and was left in place. The basket and flowers didn't pass the esthetic test, and were removed.

A small brass dish of nuts was introduced to the composition, together with a glass and jug, a paper knife and an open book. When composing a still life, you need some patience. You usually have to experiment with a variety of items in different positions before you're totally satisfied.

ADDING A PLANT
The upper left corner of the picture looked empty. The photographer wanted to introduce a plant into that area, but he didn't want to have the plant sitting on the table, within view. That, he felt, would spoil the composition. So he carefully moved a plant around until some of the leaves were in the desired position, but the main part of the plant was out of the picture area.

INTRODUCING SOFT FOCUS
The photographer was now satisfied with the composition. But he felt that a slight soft-focus effect would be appropriate. So he placed a diffusion attachment in front of the camera lens. This softened the image—particularly the highlight areas—without making it appear unsharp.

WARMING THE BACKGROUND
A graduated filter, the top half of which was an amber color and the lower half clear, was added in front of the lens. This darkened the background slightly and gave it a warmer color, while the foreground was not affected. This photo was made with the diffusion attachment also over the lens; the picture on page 71 was made without it. Compare results, and decide which you prefer. Graduated filters are available in a variety of colors. They are also available in neutral-density gray, allowing you to darken half of a picture without changing the color.

Still Life with Rear Projection

Rear projection consists of projecting the image of a slide onto a screen designed for viewing from the reverse side, rather than from the side where the projector is. To get the most uniformly illuminated projected image, it's necessary to use a special screen. This is particularly important when the projected image is to be photographed.

The still life is set up in front of the screen. A suitable scene or setting, projected onto the screen behind the still life, can form a life-like setting for the picture. One obvious advantage of rear projection over front projection is that the still life does not get in the way of the projection beam.

To use rear projection with a tabletop setup such as the one shown here, you need a room about 12 to 15 feet long.

The lighting on your still life is likely to be considerably brighter than the projected image on the screen. To get a satisfactory overall exposure, you could reduce the light level on the still life. However, there is a more satisfactory way. Give two separate exposures—an appropriately longer one for the projected background than for the still-life foreground. During the exposure to the still life, the background should be dark, and while the background is photographed, the lighting for the still life should be switched off.

1) THE STILL LIFE IS SET UP

A selection of different bread loaves had been carefully picked out at a bakery. The bread was placed on a red-and-white checkered tablecloth. One of the loaves was partially sliced and placed on a breadboard. Enough room was left for a glass of milk and a pitcher. A selection of cheeses was added in the foreground. The ears of wheat in the right foreground complement the wheat field in the projected background, as you'll see a little later. This helps to make the scene look more realistic. The lighting for this first test picture came from an on-camera electronic flash unit. Ektachrome 64 film was used.

Because all the components in this picture have a logical relationship to each other, the scene has credibility. This is an important consideration in still-life photography. Don't include things that don't belong.

2) BETTER LIGHTING ANGLE

Front lighting tends to be flat and shadowless. For this photograph, the flash head was moved to the left. This side-lighting gives distinct shadows and adds texture and depth to the components of the setup. To lighten the shadows slightly to maintain some detail in those areas, the photographer placed a white reflector card to the right side of the table. You can see some detail in the bread knife and the cheese knife, both of which are in shaded areas, as well as in the shadow sides of the loaves. Exposure and distance from the flash to the still life were the same as for the first shot.

3) CHANGE TO TUNGSTEN LIGHTING

The background was to consist of a projected image. The projector light comes from a tungsten bulb. To match the still-life illumination with the projector illumination, tungsten light was also necessary for the still life. Because Ektachrome 64 film is balanced for use in daylight, the tungsten illumination gave the distinct yellow cast seen here. Exposure was 1/8 second at *f*-16. The small aperture provided depth of field over the entire set. The camera was on a tripod, to eliminate camera shake at the relatively slow shutter speed.

4) SWITCH TO TUNGSTEN FILM

The yellow cast in the previous picture could be removed in one of two ways. A blue color-conversion filter would do the job on daylight-balanced film. The more direct way is to change to a film that is balanced for this kind of illumination. The Ektachrome 64 film was changed for Ektachrome 160 tungsten-balanced film. To fine-balance the color to suit your taste exactly, you may need to use a relatively weak light-balancing filter, either in the 82 bluish series or the 81 yellowish series. Because Ektachrome 160 is more than twice as fast as Ektachrome 64, the exposure was changed to 1/15 second at *f*-16.

5) ADDING THE BACKGROUND

The photographer selected the background from his stock of existing slides. The wheat-field scene was ideal, and the horizontal format appropriate. Remember that the projected image will appear reversed when viewed *through* the screen instead of *reflected from* the screen. If it's important that the slide appear correctly—not reversed left-to-right—you'll have to reverse it when you insert it in the projector. This can be necessary when a slide contains lettering, or when it contains a well-known and easily recognizable scene.

The lighting of the still life should be similar to that in the background scene. For example, if the background is in bright sunlight, the still-life should also be in a directional light. Shadows should fall in approximately the same direction in the still life and the background.

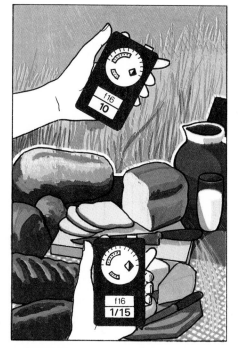

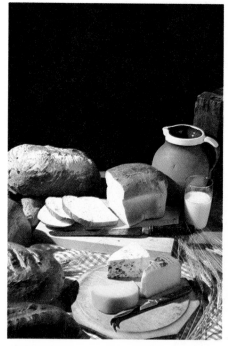

6) DETERMINING EXPOSURE
An exposure-meter reading from the still life indicated 1/15 second at ƒ-16. A reading from the projected background image indicated 10 seconds at ƒ-16. At 10 seconds, low-light-level reciprocity failure of the film would be considerable. Not only would this call for a great increase in exposure time over that indicated by the meter, but it would also cause a color imbalance in the projected image. To minimize this effect, the photographer opened the lens to ƒ-11 for the background, giving an exposure of 8 seconds. Thus, the two successive exposures would be 1/15 second at ƒ-16 and 8 seconds at ƒ-11.

7) EXPOSING THE BACKGROUND
The lighting on the still life was switched off; the projector was left on. The lens was set to ƒ-11. The camera shutter was set to B. Using a cable release, the photographer gave an 8-second exposure. Because the exposure was still dependent on the effect of reciprocity failure, it wasn't certain that the 8-second exposure would give the best result. So additional exposures at different times were made. You may prefer to determine background exposure in advance by processing a film of a series of background exposures. The projection setup must be unchanged when the final shots are made.

8) EXPOSING THE STILL LIFE
The photographer switched off the projector and turned on the illumination for the still life. To be sure the background would be perfectly black for this exposure, he draped a piece of black velvet over the projection screen. He then set his camera for multiple-exposure operation and made the second exposure of 1/15 second at ƒ-16 on the same film frame. It's important that all components of the setup remain in exactly the same positions between the two exposures. If they don't, the two images won't fit together properly on film.

9) THE FINAL PHOTOGRAPH
The final picture, opposite, looks like a genuine outdoor scene. If the two halves of the image don't match satisfactorily, either in color balance or density, you can make further exposures with different filters and exposure times.

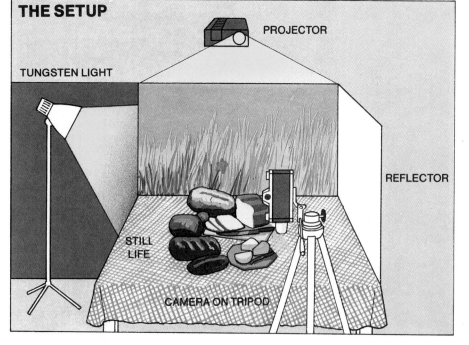

THE SETUP

PROJECTOR

TUNGSTEN LIGHT

REFLECTOR

STILL LIFE

CAMERA ON TRIPOD

◀ The projector was about 10 feet behind the screen. The still life was on a table just in front of the screen. The still life was lit from the left by a tungsten lamp, fitted with barn doors to prevent light spillage onto the screen. A reflector card on the right side of the table served to lighten the shadows. The camera with 35mm lens was on a tripod and aimed down at the still life.

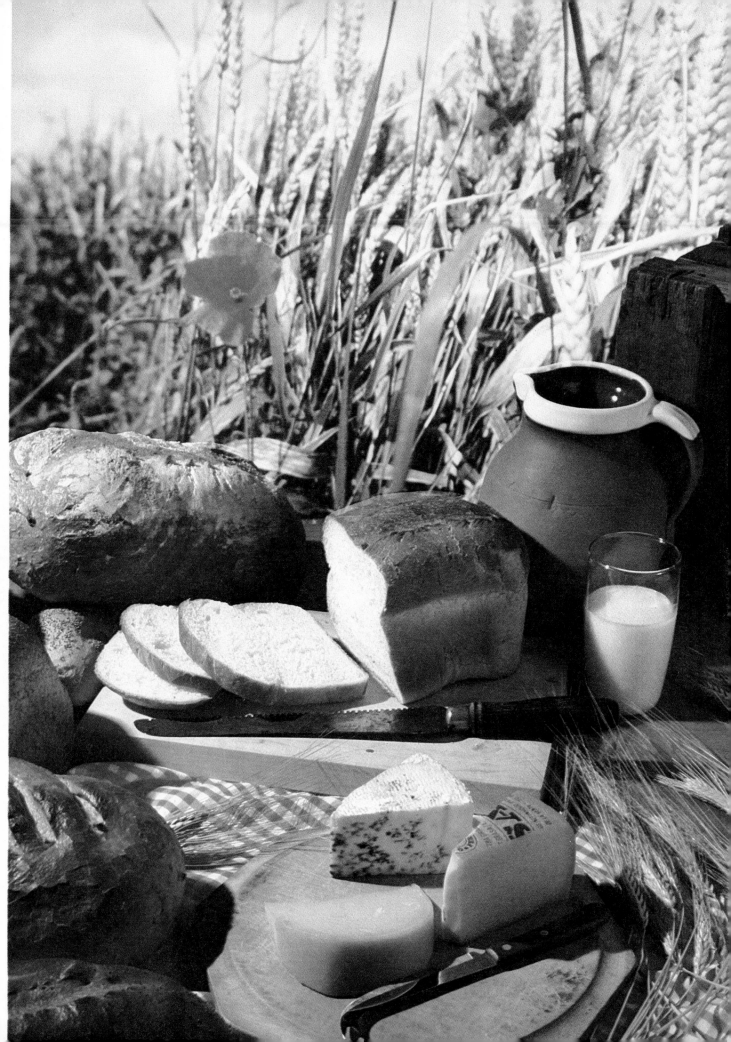

Photographing a Concert

Concerts are held in all kinds of locations—large auditoriums, small clubs and outdoors. The best locations for photography are usually obtained by special pass from the management. Generally, these passes are provided for the press and for official publicity photographers. However, there are plenty of opportunities for exciting photography for other photographers, too.

YOU MAY NEED PERMISSION

At some concerts it may be necessary for you to obtain permission to photograph. To avoid disappointment, inquire in advance whether a permit is required and where you can get it. At many concerts you are free to shoot as you wish. Management, as well as performers, generally tend to be cooperative toward photographers. After all, some photos may end up in a newspaper or other publications and be good publicity.

GET AS CLOSE AS YOU CAN

A relatively small location, such as a club rather than a huge auditorium, is preferable if you want to get close, detailed shots. Get to the location early, and try to get near the front.

The pictures reproduced here were

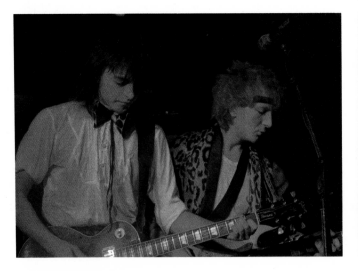

1) THE FIRST SHOT
The photo was taken from the back of a small hall, using a 50mm lens. The group is too small in the picture. Electronic flash was used because of the dim light.

2) MOVE CLOSER
The photographer moved to the front of the stage. Still using the 50mm lens, he was now able to fill the frame with the two main performers. The audience is behind him and out of the picture. Electronic flash was used again.

3) USE AVAILABLE LIGHT
Much of the atmosphere at a concert is created by the lighting. So far, the flash had destroyed this atmosphere. This available-light exposure was made at 1/60 second at f-1.8 on Ektachrome 200 daylight-balanced film.

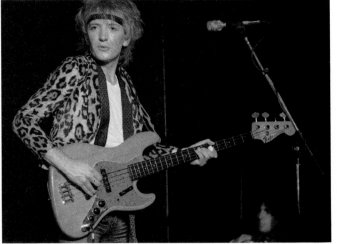

4) CHANGE FILMS
Tungsten-balanced Ektachrome 160 film was now used. Rating it at ISO 800/30°, exposure was 1/125 second at f-2.8. The 50mm lens was still used.

made by a professional photographer. To show what any photographer can do, he did not use his special privileges to shoot on stage or backstage. He mixed with the audience.

HAVE YOUR EQUIPMENT READY

It's important to have your equipment ready for shooting well before the action begins on the stage. Once the performance starts, the area around you will be very crowded and lively. It'll be difficult for you to change lenses. If you have an assistant with you to help, be sure you have discussed all your plans of action in advance. Once the music begins, you may not be able to hear yourself speak.

The professional may use as many as three cameras at a concert. Each camera will have a different lens. If he is near the stage, an 85mm lens will give him good close-ups of individual performers, a standard 50mm lens will nicely frame two group members together, and a 24mm lens provides a general view of the stage.

The average non-professional doesn't generally carry three cameras. A good alternative to three lenses is a zoom lens. It enables you to frame each shot as desired quickly and accurately. If you need to change lenses on your camera during the performance, it may be best for you to shoot a whole sequence with one lens before changing to another focal length. Many of the actions of the performers are repetitive, so you should have a chance to capture all the action you want, even in this manner.

The photographs on these pages were made with Ektachrome 160 tungsten-balanced film. The stage illumination consists of tungsten lights, although strong filters of many colors are used to color the light. For this reason it is often pointless and unnecessary to aim for *accurate* color rendition.

Avoid using flash, except possibly as a fill light. As a main light it tends to kill the specially created atmosphere of the event.

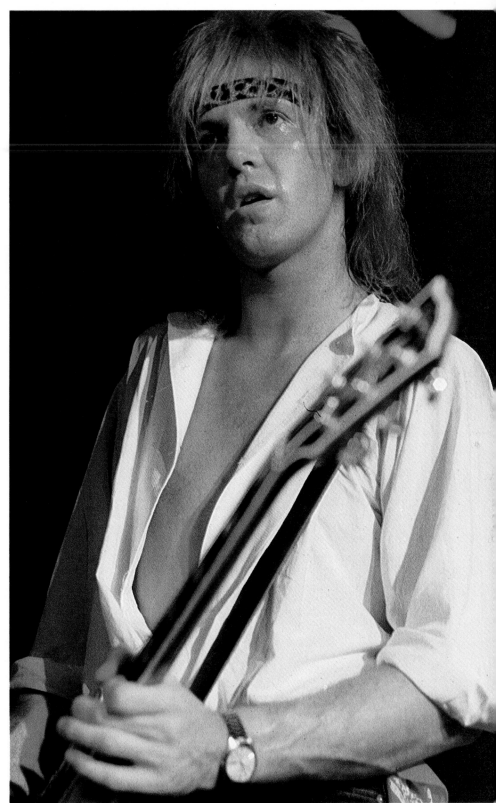

5) CHANGE THE FORMAT
For this study of one performer the vertical format seemed more suitable. An 85mm lens was used for a tighter crop. Exposure remained at 1/125 second at *f*-2.8.

YOU NEED HIGH FILM SPEED

The photos shown here were given exposures of 1/125 second at *f*-4 or *f*-2.8. The processing lab pushed the ISO 160/23° film 2-1/2 steps to a film speed of about ISO 800/30°. Kodak offers a one-step push-processing service, as do some local labs. Some custom labs may offer two- or three-step pushing of Ektachrome and other films.

If you don't want to have your film push-processed, you can use 3M 640-T tungsten-balanced color slide film. It has a speed of ISO 640/29°.

SHOOT PLENTY OF FILM

To be sure of getting the pictures you want, take plenty of exposures. You are likely to be jostled by the crowd, and this could cause blurred images. Also, you can't predict the rapid movements of a performer and sometimes he will have jumped out of your image frame by the time you make the exposure.

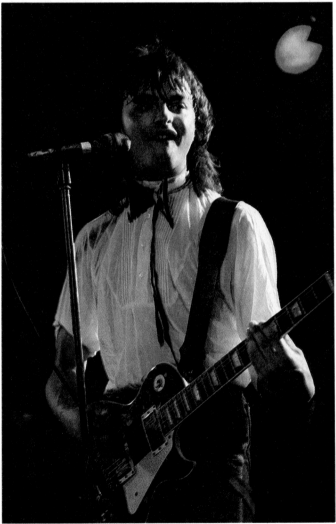

6) CHANGE OF SUBJECT
This shot, of a different performer, is similar to the previous one. The lens and exposure were the same. In both pictures the illumination is from the front. You can't control the lighting, but you can watch out for dramatic back or side lighting, as recorded in the next photograph.

7) BACK LIGHTING
When back lighting is used, take advantage of it. It can give you some really dramatic pictures.

8) THE CHOSEN SHOT
This was the photographer's choice of best shot of the evening. It includes both back and front lighting. There's action and there are colored lights. You can even see the smoky atmosphere of the hall.

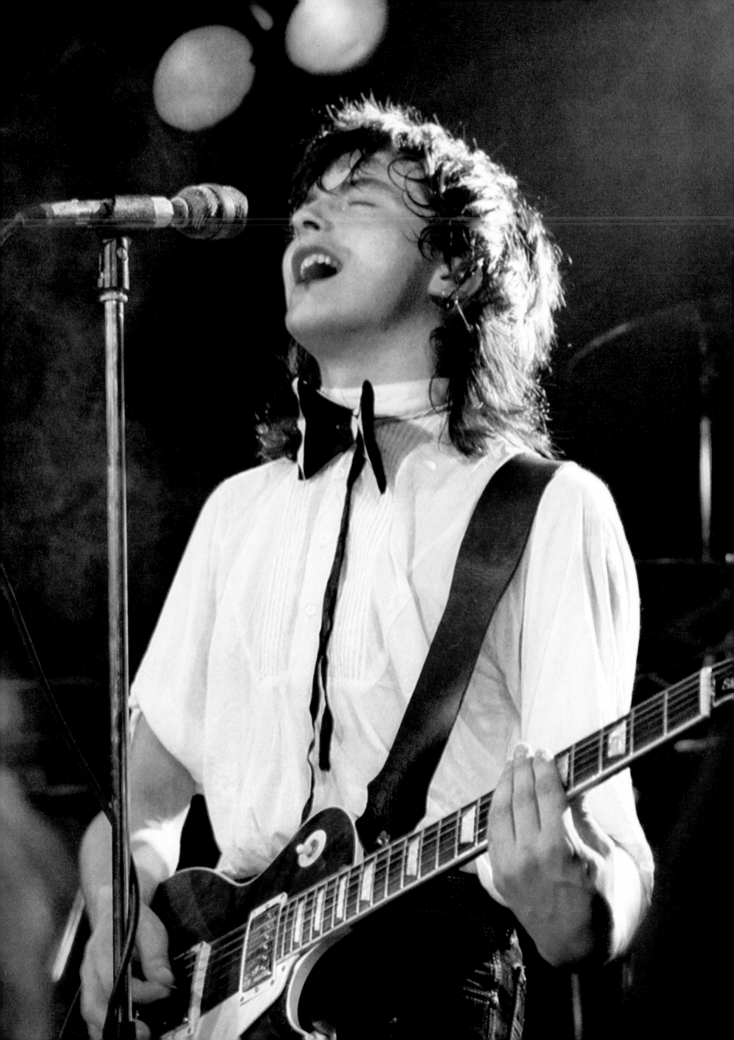

Pet Portraiture

The photographs in this section were made by a specialist in animal photography. She lives in the country, in a home surrounded by cats, dogs, chickens, rabbits, hamsters and a variety of other animals.

From this wide selection, a pair of kittens was selected for photography.

They represent the kind of animal most photographers are likely to have easy access to. They also present a challenge—they are independent and mobile.

▲ A SNAPSHOT
Two cats on a chair, lit by a strong beam of sunlight through a window. A picture that is common in family photo albums. However, a professional animal portrait needs more.

▲ THE SET
An old tractor wheel and some ragwort provided an authentic outdoor scene—right in the studio.

▶ THE RESULT
Black velvet was draped behind the wheel, to darken the background. Electronic flash was used, to stop all possible movement on film. The film was Ektachrome 64; the lens aperture was set to f-16.

BETTER CONTROL INDOORS

In spite of all the outdoor space available, the photography was going to be done indoors. Not only does this provide better control of lighting; it also makes it easier to control the animals and prevent them from being distracted and running away.

You can't order a cat to pose for you. You can either photograph it as you find it or, if you want more control, you can construct a set that will confine it to a relatively small space. When you have the cat restricted to a small area, you can concentrate on its antics and trip the shutter when you see a good picture.

The top picture on page 82 is a simple snapshot of two kittens. This is the way most people would take such a picture. The setting is not attractive and the lighting is harsh. And it's very easy for the cats to jump down and run away whenever they feel like it. Here we'll show you how to prepare a special set to make an excellent pet portrait.

PREPARE THE SET

While the cats were in another room, the photographer got to work building a set, using an old tractor wheel as the central element. The wheel was raised well above floor level, to make it less likely for the cats to jump off and run away. The crop in the picture would be tight so the viewer could not see that the wheel was raised. It would appear to be resting on the ground.

A few bunches of ragwort were added to contribute some color and to give the impression of an outdoor scene. The ragwort was placed in vases of water to keep it fresh-looking for as long as possible. The vases were carefully hidden from view.

MAKE A TEST PHOTO WITHOUT THE ANIMALS

The lighting was added, an exposure reading made, and a Polaroid test photo was shot—all without the cats. Only when the lighting and exposure looked right was it time to bring in the cats.

A Hasselblad medium-format camera was used because the composition lent itself particularly well to the square image format. A 150mm lens, which is a moderate telephoto for the Hasselblad, was used.

The kittens were brought in and the door was closed. As soon as they were placed on the wheel, the photographer was ready to shoot. Sometimes the first few seconds provide the best opportunities for attractive pictures. But not this time. The kittens jumped off and ran to the door.

The photographer wasn't surprised. She explained that the kittens don't like the metal wheel because they can't get their claws into it. She persevered, returning them to the wheel every time they jumped off, and tripping the shutter whenever she saw an attractive picture.

The flash didn't seem to trouble the kittens. They seemed more aware of the sound of the camera shutter. Sometimes it made them look at the camera, which gave a good picture, and at other times it had a less positive effect.

LIGHT THE SET
Shooting by available light was out of the question in the indoor setting, especially with the short exposure time needed to stop the active kittens. Five studio flash units were used. They were positioned carefully to avoid conflicting multiple shadows.

YOU NEED A LOT OF PATIENCE AND FILM

Taking good animal portraits takes a lot of patience, and a lot of film. You can't give orders to kittens, so you need an alert eye. Be prepared to keep shooting until you think you have an adequate selection, because you'll find that many of your exposures came just a fraction of a second too early or late. An autowinder on the camera enables you to make many exposures in a short time.

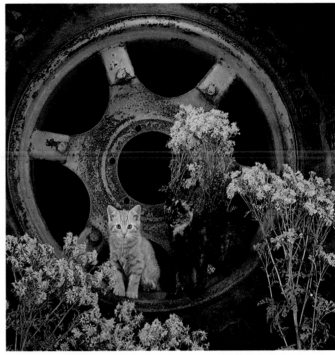

BRING IN THE KITTENS
The kittens were placed on the wheel. After jumping off a couple of times, they began to explore the set that had been constructed for them. After the photographer had taken a few pictures, she realized that the background might look a lot better if it were dark.

DARKEN THE BACKGROUND
A piece of black velvet was draped behind the wheel. This eliminated the unattractive multiple shadows behind the wheel. They were a giveaway that the pictures were made in a studio with several light sources.

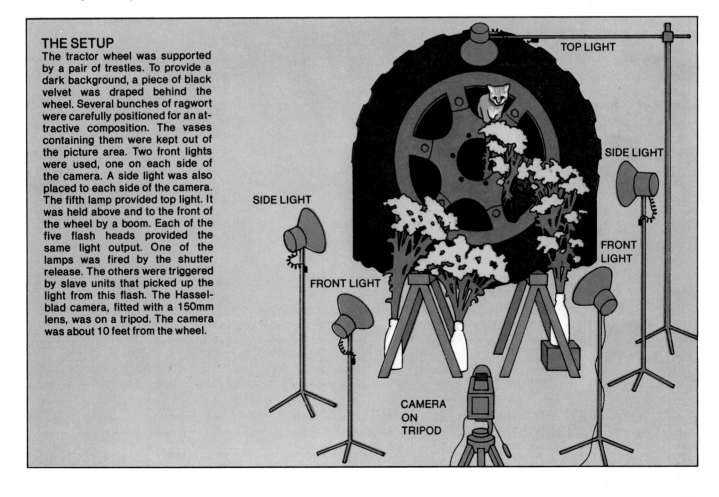

THE SETUP
The tractor wheel was supported by a pair of trestles. To provide a dark background, a piece of black velvet was draped behind the wheel. Several bunches of ragwort were carefully positioned for an attractive composition. The vases containing them were kept out of the picture area. Two front lights were used, one on each side of the camera. A side light was also placed to each side of the camera. The fifth lamp provided top light. It was held above and to the front of the wheel by a boom. Each of the five flash heads provided the same light output. One of the lamps was fired by the shutter release. The others were triggered by slave units that picked up the light from this flash. The Hasselblad camera, fitted with a 150mm lens, was on a tripod. The camera was about 10 feet from the wheel.

TOP LIGHT

SIDE LIGHT

SIDE LIGHT

FRONT LIGHT

FRONT LIGHT

CAMERA ON TRIPOD

A Day at the Seaside

One important difference between a professional photographer and an amateur is the amount of film each is prepared to shoot on any one project. The professional, who must be absolutely certain of getting the pictures his client needs, will shoot lots of film. He'll be paid for his work and for the film he uses. The amateur, however, finds film relatively costly, and will do all he can to use it sparingly.

In this section, we're going to give you an idea of the kind of pictures you can shoot during one day at the seaside. The photographs were made by a professional. However, to treat the subject realistically from the amateur's point of view, we did not allow the professional unlimited film usage. To be specific, we limited him to just one 36-exposure roll of 35mm film for the day.

PLAN AHEAD

To get the most from one roll of film, careful planning was essential. This required an initial study of the resort being photographed. A little library research in advance helped. Early on the day of shooting, an observant walk around the resort provided some good ideas. There should be plenty of variety in the pictures —people, the ocean, still-life studies, distant shots and close-ups, the use of various filters, and so on. Indoors, there could be gift shops and arcades.

Planning a day's shooting outdoors should take into consideration the position of the sun as it moves across the sky. If you plan to photograph certain buildings and scenes, make a note early in the day as to when the lighting will be best. Then shoot your pictures in the order called for.

WORK WITH CARE

With just one roll of film, the photographer had to be sure of his exposures before shooting, because he couldn't afford to bracket exposures extensively. He also had to have a clear plan of what he wanted to shoot. Just like the economy-conscious amateur!

The weather conditions varied. Throughout the day there were heavy clouds and dim light one moment, and bright sunlight the next. The photographer chose to take a roll of Ektachrome 64 film, rather than high-speed Ektachrome 400. He thought he would get better image quality, and was prepared to gamble on having sufficient light for the slower film.

Outdoor exposures varied from 1/250 second at f-11 to 1/125 second at f-4. Some of the indoor exposures were as long as 1/4 second at f-5.6.

Don't be afraid of bad weather. You can get excellent atmosphere shots under heavy clouds, in mist or after heavy rain. Heavy ocean waves can also be the subject of dramatic photographs.

TRAVEL LIGHT

Equipment should be kept to a minimum. One camera and a couple of lenses are sufficient. To take the pictures reproduced on these pages, the photographer took two lenses—a 35-70mm zoom and an 80-200mm telephoto-zoom. He also took a few filters. They included a polarizing filter, in case the sun appeared, and a blue graduated filter, in case it didn't. A yellowish 81C filter was also included, to warm up skin tones.

TAKE NOTES

As you take your pictures, take notes. It's incredibly easy to forget important details about your subjects or scenes, especially when you're shooting all day. When your film comes back from the processing lab, you want to be able to identify and caption each picture accurately.

DON'T BE AFRAID TO ASK FOR HELP

When you want people's cooperation, don't be afraid to ask. Ask people to pose for you, or ask shopkeepers to permit you to photograph through their windows. Sometimes, you may want to ask someone to move *out of the way* of something you're trying to photograph. Generally, people will oblige. If they don't, you've lost nothing.

On the opposite page we've reproduced a contact sheet of the day's shooting. Notice the variety. There are near shots and distant views; people pictures and object pictures; indoor and outdoor shots. There's also a variety of color.

POINTS TO REMEMBER
- Research your location beforehand.
- Travel light.
- Get the "feel" of the place before you shoot.
- Keep an eye on the sun's movement and plan your shots accordingly.
- Plan for variety in your pictures.
- Keep notes, so you can caption your photos later.

▶ These are contact prints of the entire roll of film, representing one day's shooting at a seaside resort.

A DAY'S WORTH OF GOOD PHOTOS

You may want to try an assignment like this—one roll of film for one day's shooting. When your pictures have been processed, pick out your favorites and arrange them in an album. These two pages give you a good idea of an attractive layout.

Select pictures that show the variety of your day. Include some pictures of people and others of objects. Show some outdoor scenes and some photos taken indoors. Put together a balance of colors, so that no one color dominates the spread. Choose some vertical-format photos and some in the horizontal format.

Your layout will appear much more attractive if you have enlargements made in dif-

ferent sizes, as shown here. Some pictures naturally call for a larger size. The seascape at the lower right is a typical example. Others, like the pinball machine, can be presented in a relatively small format.

If you want to write descriptions of your photographs and add them to the layout, you can do this in one of two ways. Either write a short caption for each, allowing room next to or under each picture for it. Or, write a couple of paragraphs about all the pictures, and present them in one block or box, in a suitable location on the spread.

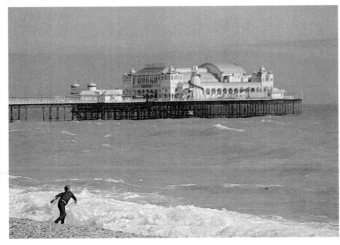

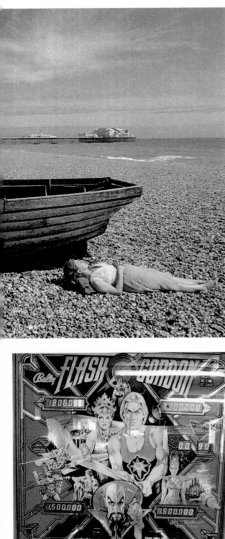

Framing Your Best Photos

Throughout this book we've provided you with technical know-how and creative ideas to help you produce better photographs. Now you can try some of the suggestions we've made.

When you've taken a really attractive picture, don't store it away in a box, where no one will ever see it. Too many good photographs end up this way. Enlarge your favorite photos and mount and frame them for display. The pictures on pages 92 and 93 show an expert at work. Follow him carefully. There's no reason why your photos shouldn't look just as good as his.

LEAVE A BORDER

Prints you plan to frame should have a sufficiently large border—at least 1/4 inch on each side. You'll be placing a cut-out window, known as a *mat,* on top of the picture. The border should be wide enough to sit firmly under the edges of the mat. A print border also makes it easier to handle your prints without touching the image area.

An expert can cut a mat, mount and frame a photograph in about ten minutes. At first, it may take you half an hour to do a good job, but with a little experience you'll speed up.

PREPARE THE MAT

The most difficult part is cutting the mat. It's not just a matter of cutting a hole in a piece of card. The hole has to be the right size and in the right position. Sometimes you may not want to reveal the entire photograph, but crop it tightly for a better composition. To achieve what you want, you must make careful measurements.

The opening in the mat should be centered on the card left to right, but should lie a little higher than center. It's common to leave about 45% of the total border at the top and about 55% at the bottom.

BEVEL THE MAT BORDER

The border of the mat looks much more attractive if it is *beveled* to slope into the image area, instead of being cut straight down. Special mat cutters for this purpose are available from art-supply stores.

To cut in a straight line, use a metal rule or some other solid straight edge as a guide. Use it the same way you would use a ruler to draw a straight line.

When you've got a good mat, the rest of the framing process is easy. Follow the directions on pages 92 and 93. Our expert selected the photograph reproduced on page 53 for his demonstration. You can see the framed result on the opposite page.

▲ WHAT YOU NEED
Select a frame that is to your taste and suits the picture. You'll need some card as backing for the print and for the mat. You'll also need adhesive tape and corner mounts. Be sure all the materials you use are of *archival quality,* so they do not cause your photograph to deteriorate with time. Your photographic dealer and art-supply store will be able to advise you.

You'll need a compass, ruler, pencil, screwdriver and mat cutter. Also be sure to have glass cleaner, a cotton cloth, and a small weight. A calculator is helpful but not essential.

▶ THE FINAL RESULT
Here's a professional portrait, displayed in a professional way. By following the steps on the next two pages, you can do as well.

STEP BY STEP

Before you start, get all your materials and tools ready. A 12x16 inch frame was chosen for the 8x10 enlargement of the mother and baby. This allows for a generous border and creates an attractive display. A light cream color was chosen for the mat. It is bright and cheerful and seems appropriate for the subject of the picture. The card used as backing for the photograph can be white.

1) Place the enlargement approximately in the center of the back of the mat board. Set the compass to the distance from just inside the image to the edge of the mat board.

2) Be sure this distance is equal for both sides. Then use the compass to draw a line down each side of the mat to mark the image border.

6) With the compass still set to the same distance, draw a line across the top of the mat to mark the top border of the image.

7) Place the print in its correct position, using the side and top lines as a guide. Set the compass to the distance from just inside the image to the bottom of the mat.

8) With the compass set to this distance, draw a line across the bottom of the mat. You have now marked out the four borders of the image of the picture.

12) Using this piece of paper as a guide, place the straight edge in the right position for cutting the borders of the mat.

13) Start and end each cut about 1/10 inch beyond the outline you had drawn on the board. This will allow for bevelling. Cut all four sides in the same way.

14) Line up the support card with the mat board, which is still face-down. Stick the two together with tape.

18) Open the frame, preferably on one of the longer sides. Frame designs differ. Here, the screws have been loosened, the clips taken out, and one side removed.

19) Remove the cover glass and the hardboard backing. Clean both sides of the glass carefully with glass cleaner. Let the glass dry thoroughly.

20) Place the mounted print face down on the glass. Then add the hardboard backing.

3) Line up the top edge of the image with the top edge of the mat. Measure the distance from just inside the bottom edge of the image to the bottom of the mat.

4) Multiply this distance by 0.45 and set the compass to the resulting length. This will be the width of the top border.

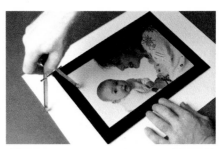

5) Line up the image with one of the side lines on the mat. Use the compass to position the image at the right height, parallel to the borders of the mat.

9) Set the mat-cutter blade to the correct depth for thickness of the mat. It should cut through the entire thickness and just a little beyond.

10) Put another piece of card below the mat to protect the blade. Using a straight edge as a guide, make a trial cut in the center of the mat board.

11) Line up a small straight-edge piece of paper with the straight edge of the mat board. On the paper, mark how far from the straight edge the cut occurred.

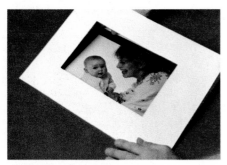

15) Place the print on the support card. Fold over the mat and adjust the position of the print until it is framed properly.

16) Place a small weight on the print to hold it in place. In this illustration, it's wrapped in tissue to prevent scratching the print. Open the mat.

17) Without touching the image area, lift up each corner of the print in turn and attach a corner mount. Push each down firmly to adhere to the support card.

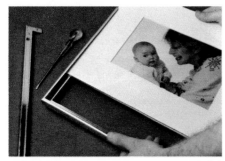

21) Turn the whole assembly over and slide it into the frame on the open side.

22) Turn the frame over and close it. In this example, the fourth side is replaced, the clips are put back, and all the screws are tightened.

23) Turn the frame over again. Give a final wipe to the glass and the frame. You're now ready to display your picture.

SELECTION CHART FOR COMMONLY USED FILTERS

FILM TYPE	DESIRED RESULT	LIGHT ON SCENE	VISUAL COLOR OF FILTER	HOYA	TIFFEN	VIVITAR	BDB FILTRAN	FILTER FACTOR (Approx.)
Any	Reduce UV exposure of film	Day	Clear	UV	Haze 1	UV-Haze	UV-Haze	1X
	Reduce amount of light 2 steps without affecting colors	Any	Gray	NDX4	ND 0.6	ND-6	ND4X	4X
	Reduce amount of light 3 steps without affecting colors	Any	Gray	NDX8	ND 0.9			8X
	Soften facial lines in portraits, soften lines in any image	Any	Clear	Diffuser	Diffusion Filter #1	Soft Focus	Soft Focus	1X
	Increase softening effect	Any	Clear	Soft Spot	Diffusion Filter #3			1X
B&W	Darken blue sky and sea, lighten clouds for contrast	Day	Light Yellow	K2	6	K2	Yellow	1.5X
	Stronger sky/cloud contrast, lighten yellow and red	Day	Dark Yellow		9	G-15		2X
	Outdoor portraits, natural reproduction of foliage	Day	Green	X1	11	X1	Green	2X-4X
	Improve contrast of distant landscapes, penetrate haze	Day	Orange	G	16	O2	Orange	3X
	Exaggerate sky/cloud contrast, dramatic landscapes	Day	Red	25A	25A	25(A)	Red	8X
Day-Light COLOR	Reduce blue effect of open shade, overcast days, distant mountain scenes, snow	Day	Very Faint Pink	1B	SKY 1A	1A	Skylight 1A	1X
	Warmer color in cloudy or rainy weather or in shade More effect than Skylight filter	Day	Pale Orange	81C	81C	81C	R1-1/2	1.5X
	Reduce red color when shooting daylight film in early morning or late afternoon	Day	Light Blue	82C	82C		B 1-1/2	1.5X
	Use with daylight film for shooting with clear flashbulbs at night or indoors	Clear Flashbulb	Blue	80C	80C	80C	B6	2X
	Normal color when exposing daylight film under 3400K tungsten lighting	Tungsten	Blue	80B	80B	80B	80B	3X
	Normal color when exposing daylight film under 3200K tungsten lighting	Tungsten	Dark Blue	80A	80A	80A	80A	4X
	Reduce blue-green effect of exposing daylight film under fluorescent lighting	Fluorescent	Purple	FL-D	FL-D	CFD	DAY FL	1X
Tungsten COLOR	More natural color with tungsten film exposed by daylight in morning or late afternoon	Day	Amber		85C		R3	2X
	Natural color with tungsten Type A film exposed by midday sunlight	Day	Amber	85	85	85	85	2X
	Natural color with tungsten Type B film exposed by midday sunlight	Day	Amber	85B	85B	85B	85B	2X
	Reduce red effect of shooting tungsten films under ordinary household incandescent lights	Incandescent	Light Blue	82C	82C		B 1-1/2	1.5X
	Reduce blue-green color effect of shooting tungsten film with fluorescent lighting	Fluorescent	Orange		FL-B	CFB	ART FL	1X

NOTE: Filters made by different manufacturers are not represented to be exact equivalents even though labeled the same or designated for the same purpose. These filters should be approximately equivalent and satisfactory for the indicated uses. Filter factor may vary with brand.

Index

Front Cover Photos:
Landscape by William M. Anderson
Still life by Steven Meckler
Portrait by Balfour Walker Photography
Back Cover Photo:
Graeme Harris

8.213258128